ODDS OFF

or, L'Amour Foutu

MATT MADDEN

HIGHWATER BOOKS

Odds Off, or, L'Amour Foutu by Matt Madden

Publisher: Tom Devlin
Production Design: Matt Madden and Tom Devlin
All Contents Copyright © 2001 by Matt Madden
First Printing: April 2001
Printed in Canada

ISBN 0-9665363-9-8
10 9 8 7 6 5 4 3 2 1

Highwater Books
P.O. Box 1956
Cambridge MA 02238
(617) 628-2583
www.highwaterbooks.com

Contact the Author at: matt@imaginot.com

Thanks:
Jessica Abel, Tom Devlin, Tom Hart, Dean Haspiel, Jason Little

Special Thanks for Linguistic Consultation:
Lili Meisamy, Tanitoc, Gregg Trowbridge

For Jessica

ODDS OFF

1.

JANUARY 1, 1998
AUSTIN, TEXAS

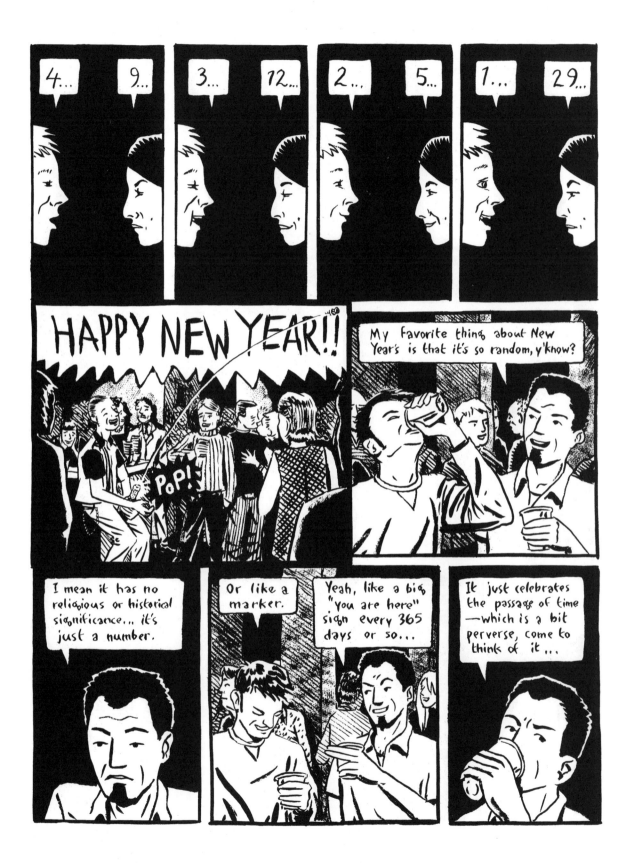

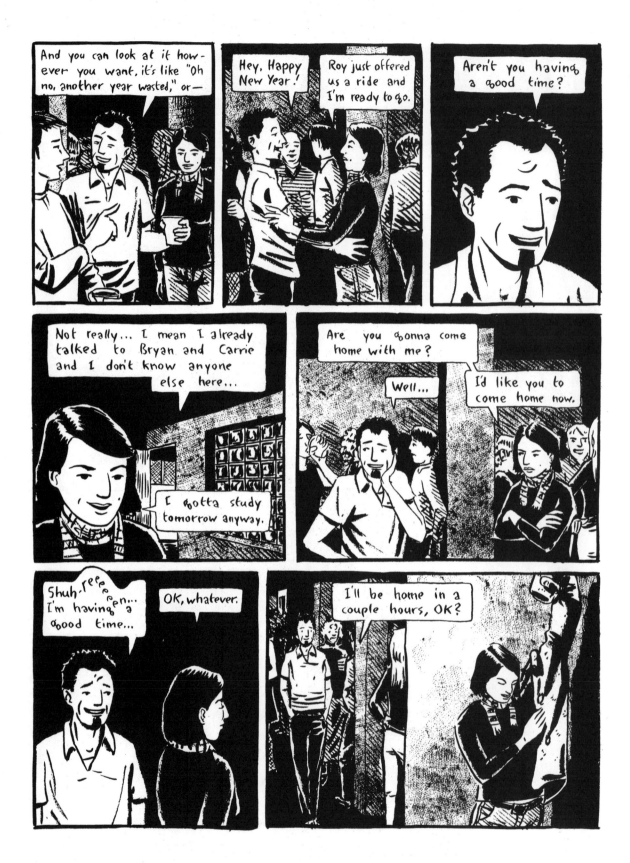

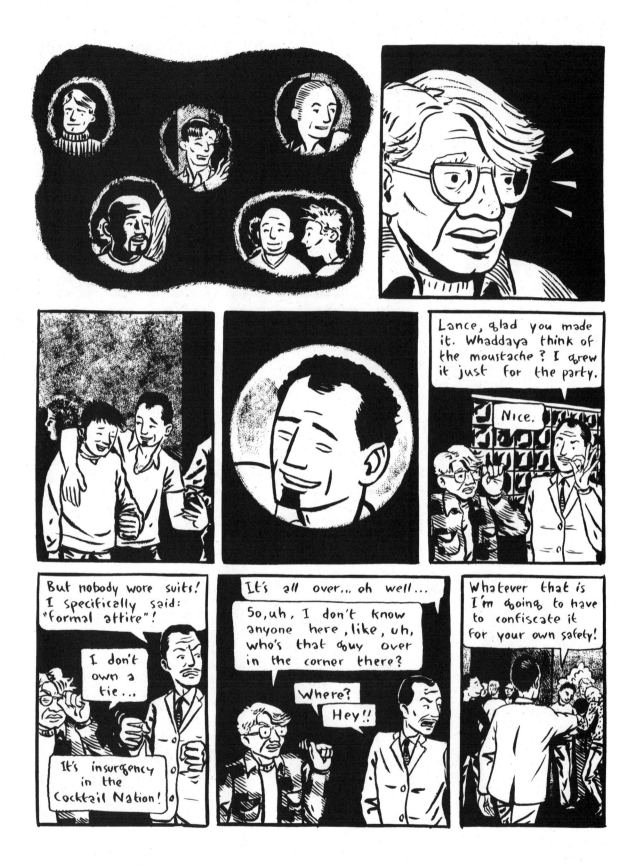

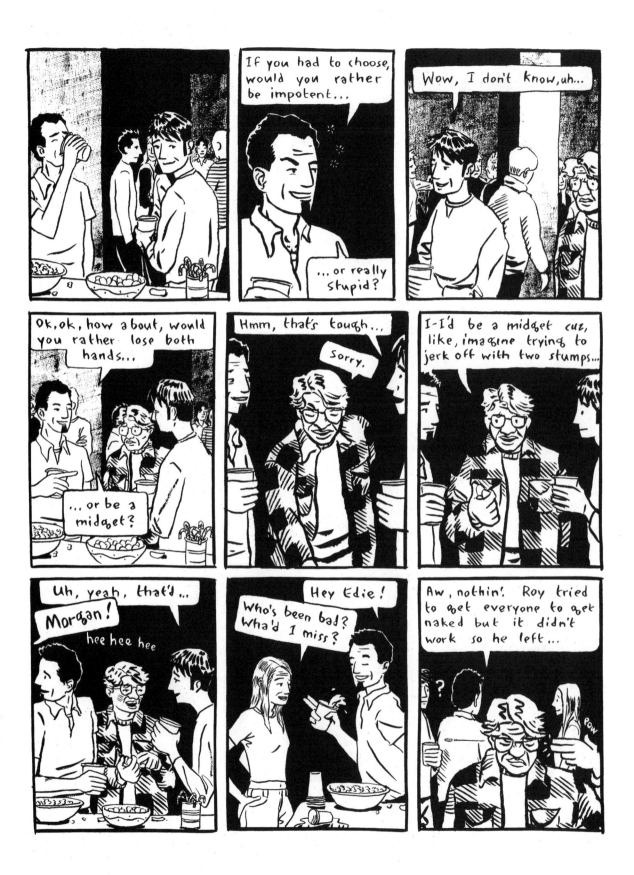

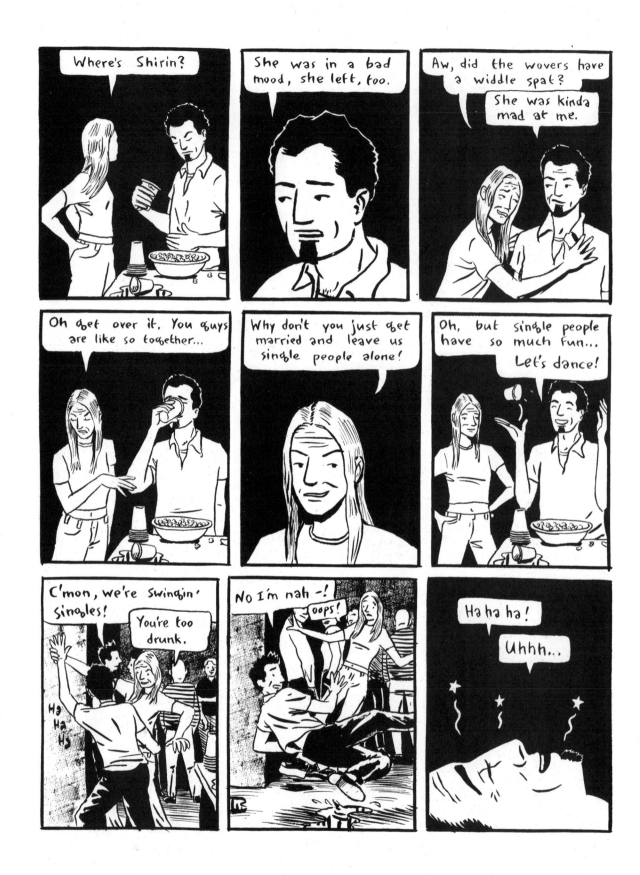

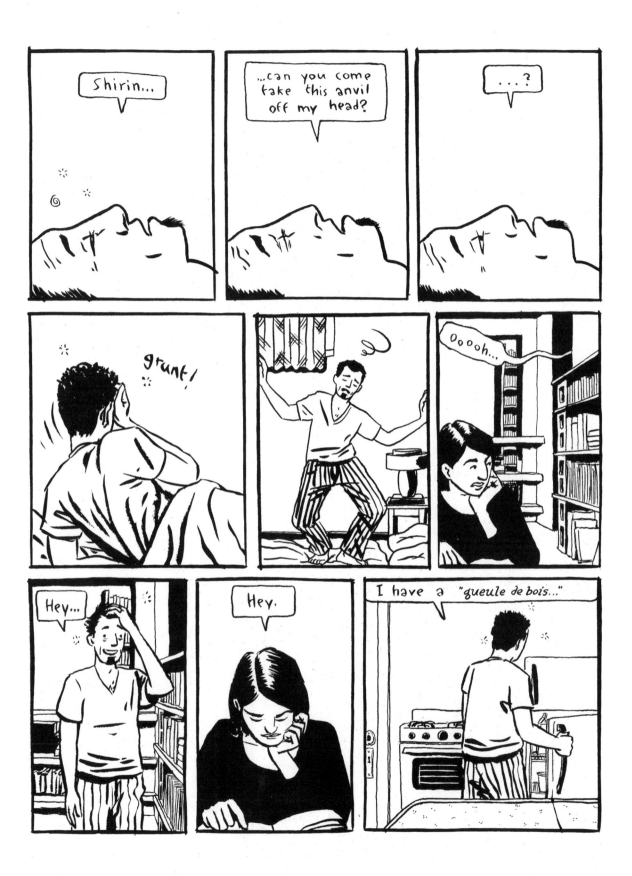

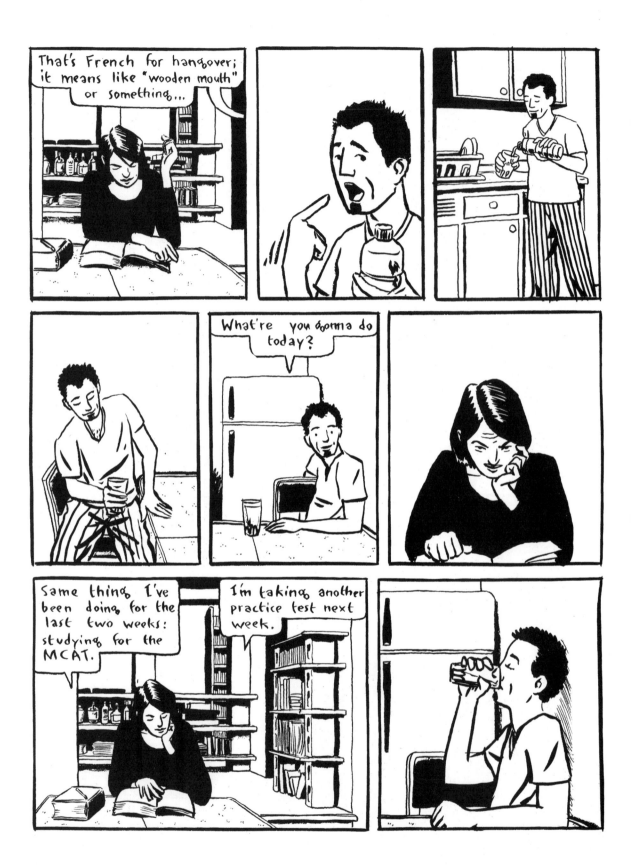

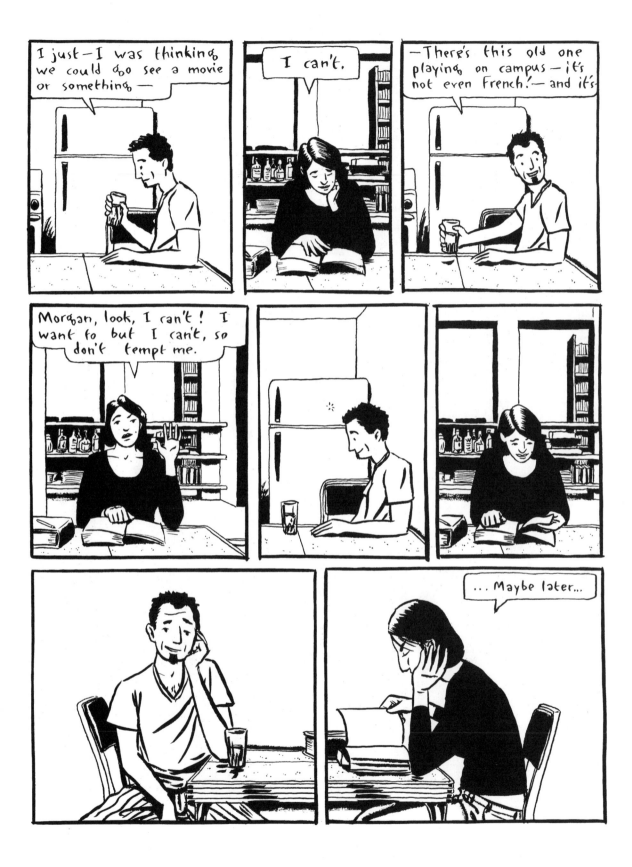

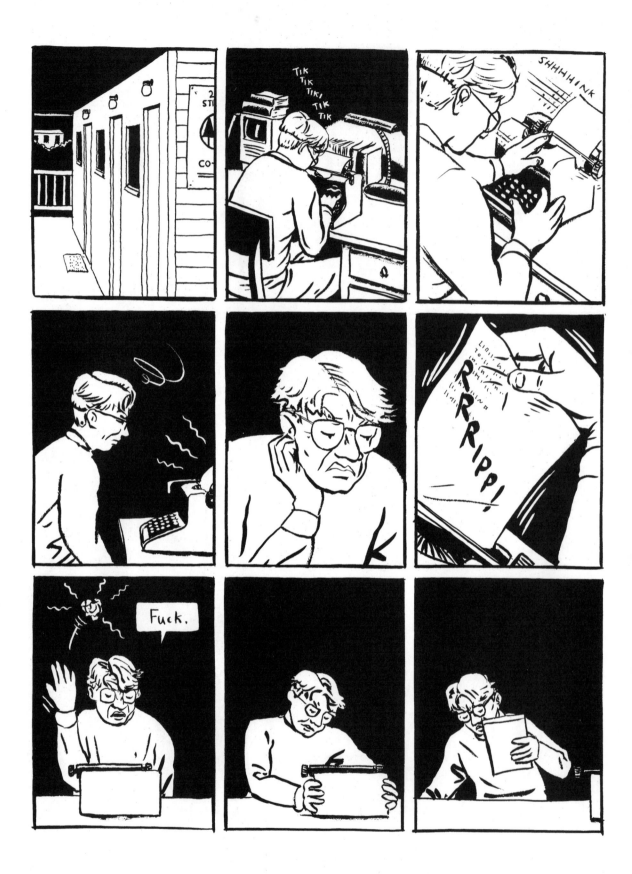

2.

FEBRUARY 14

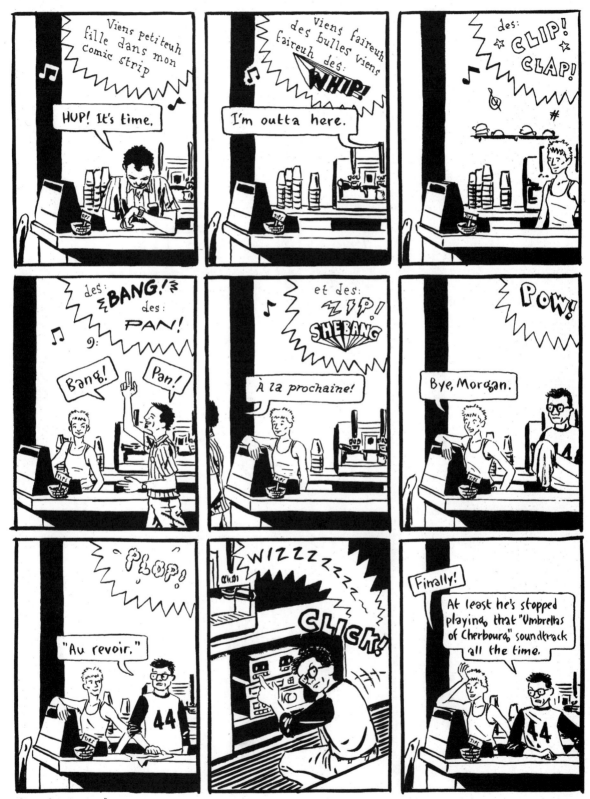

Serge Gainsbourg – "Comic Strip"

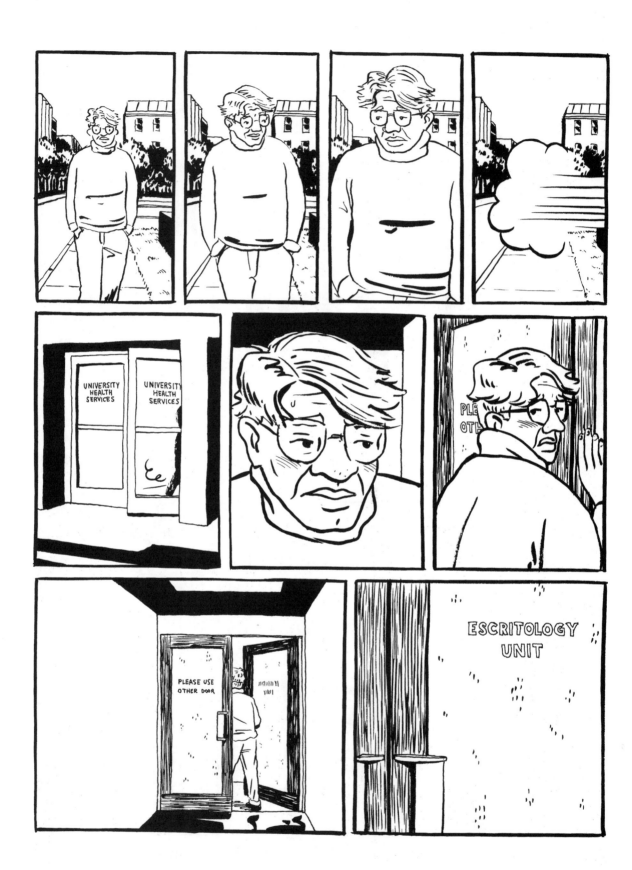

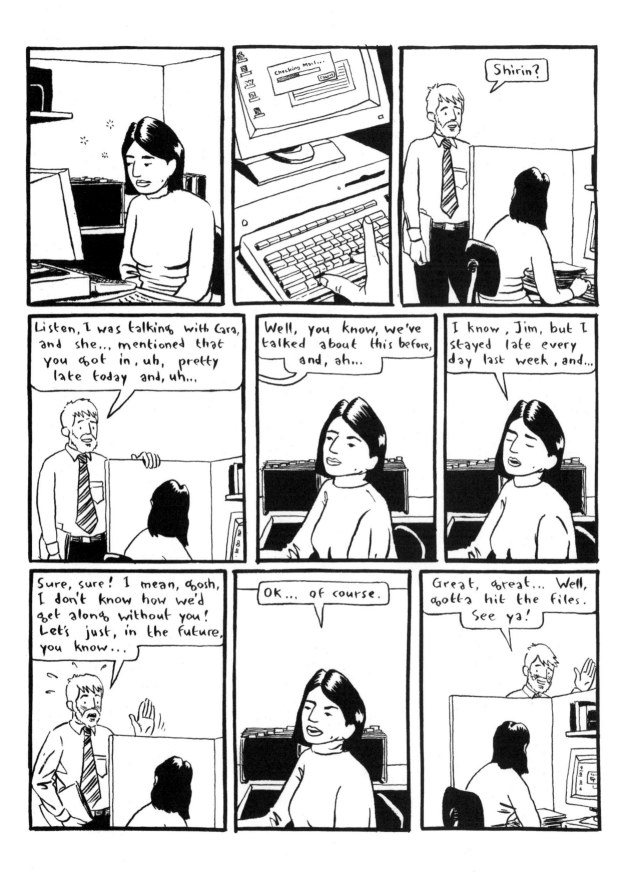

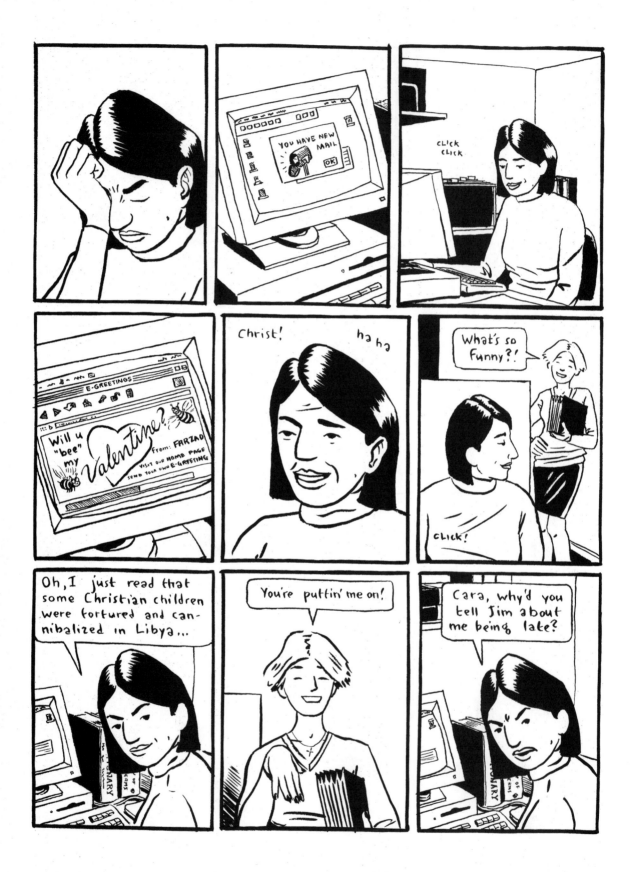

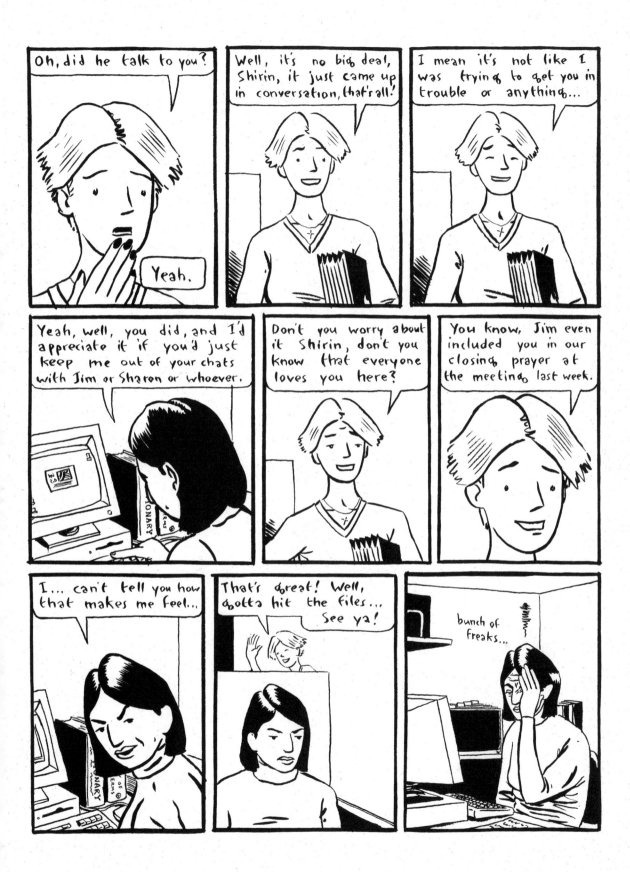

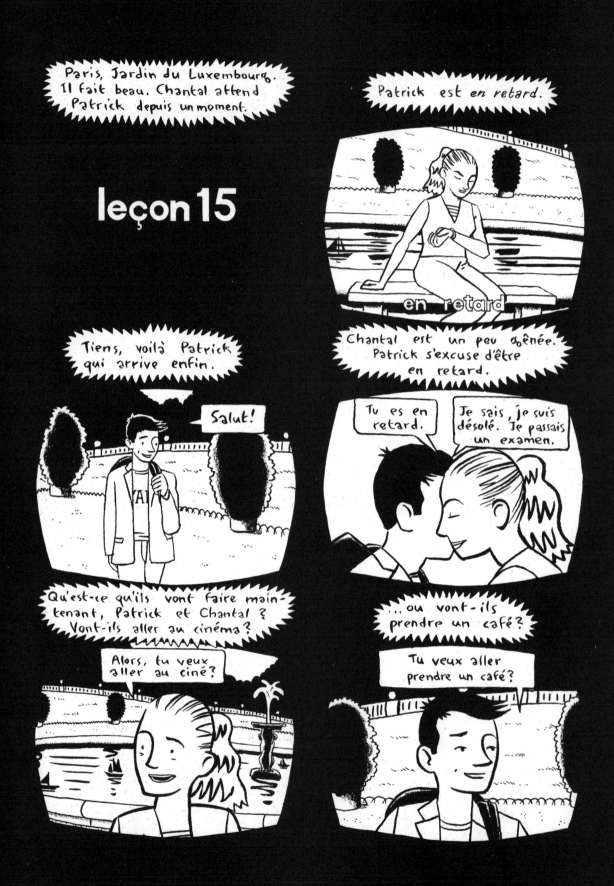

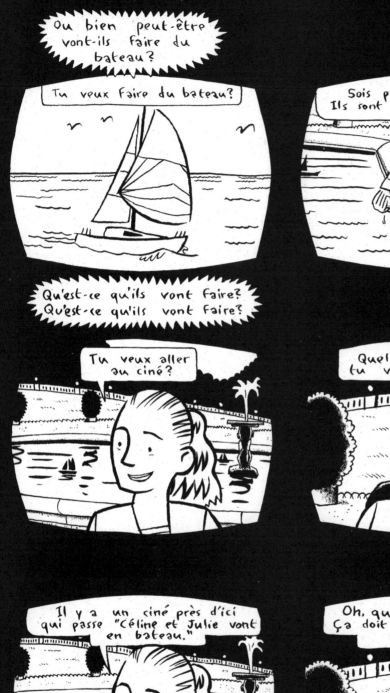

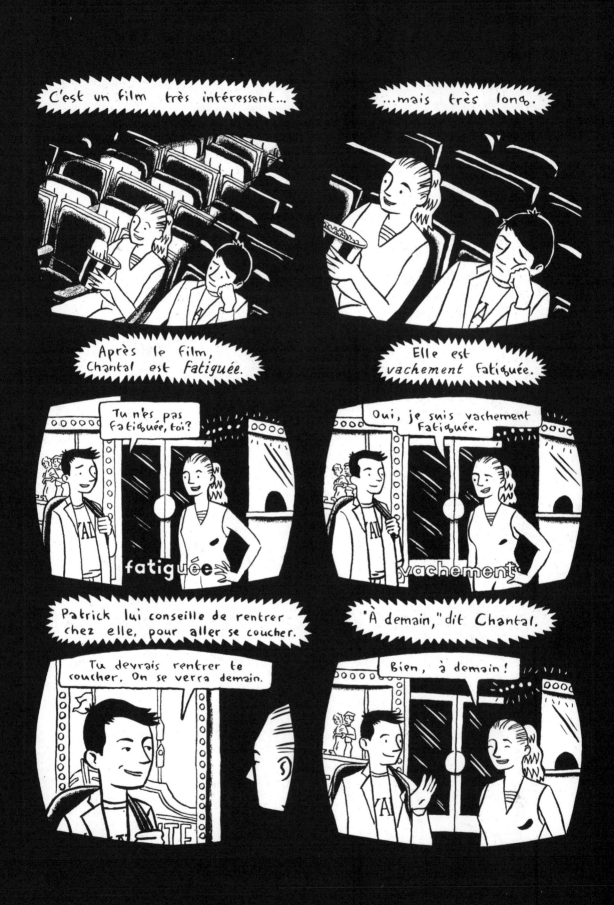

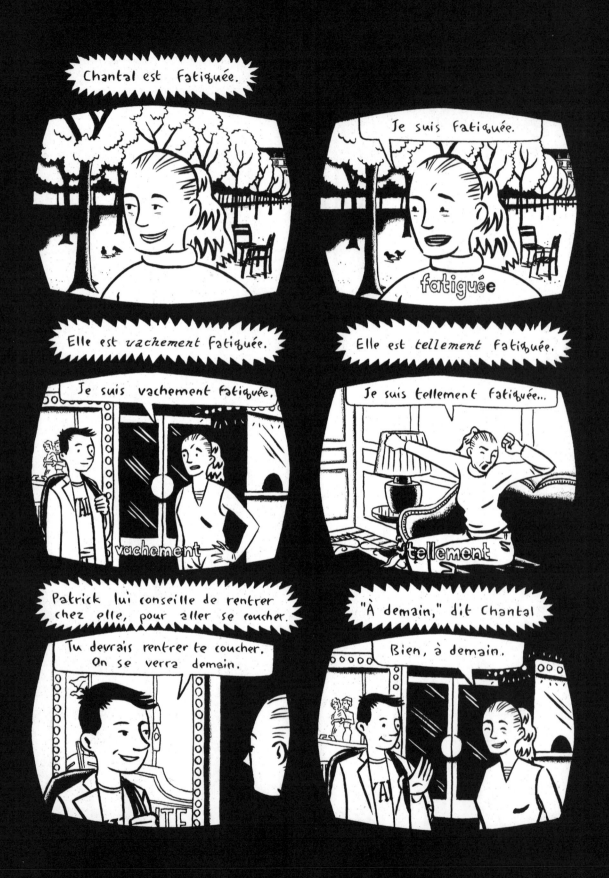

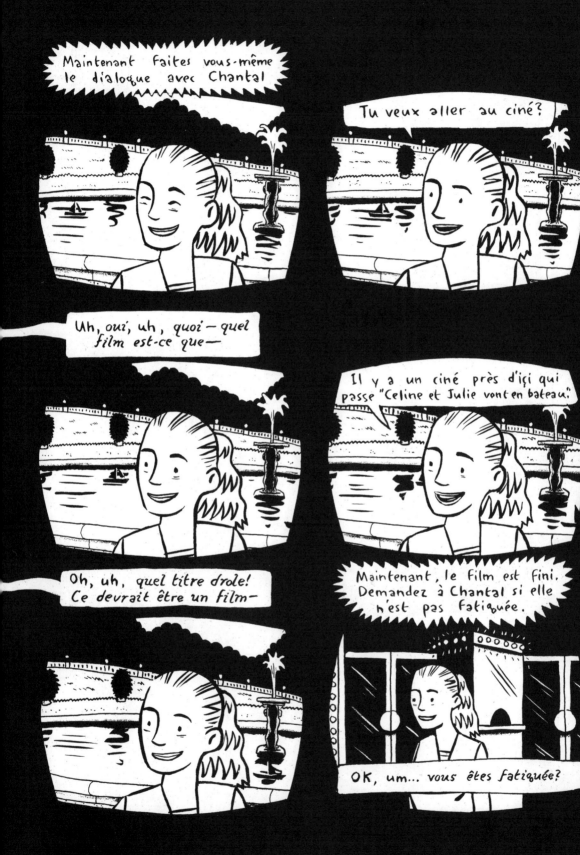

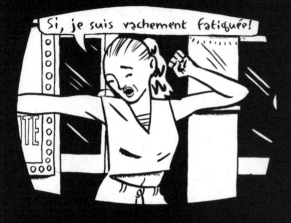

KLICK

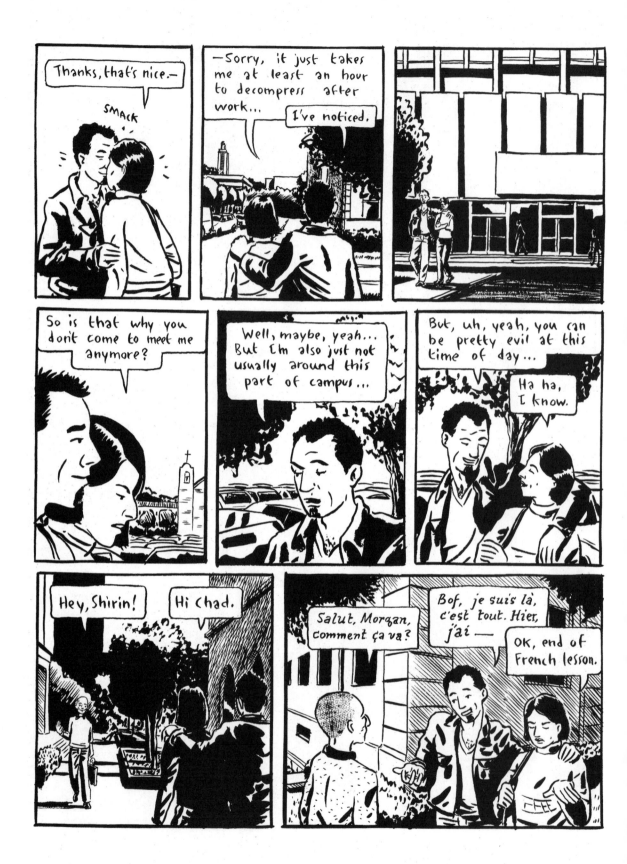

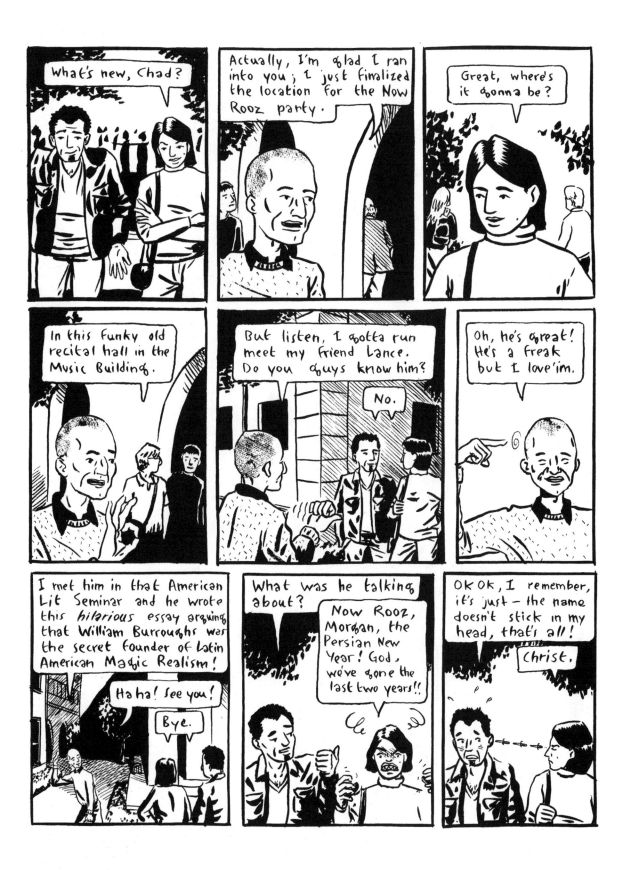

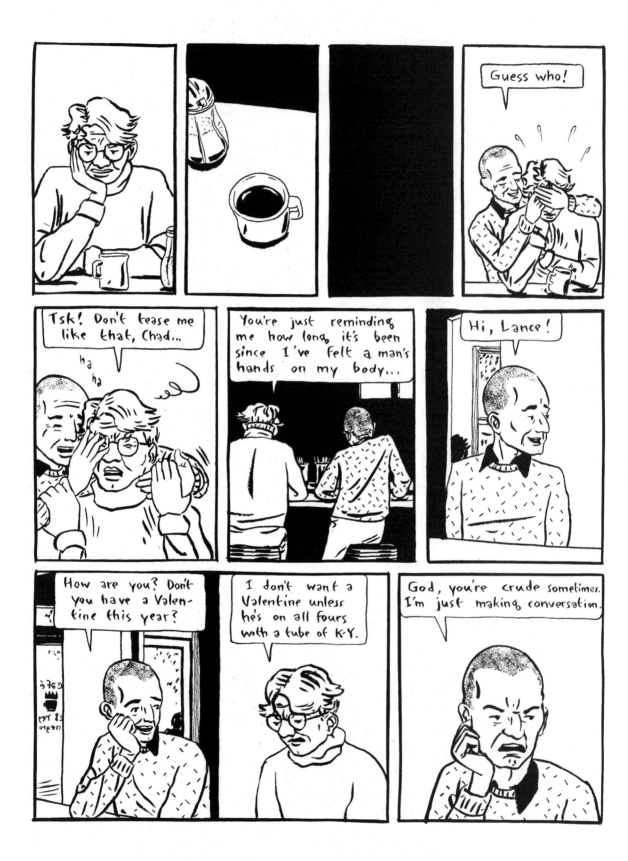

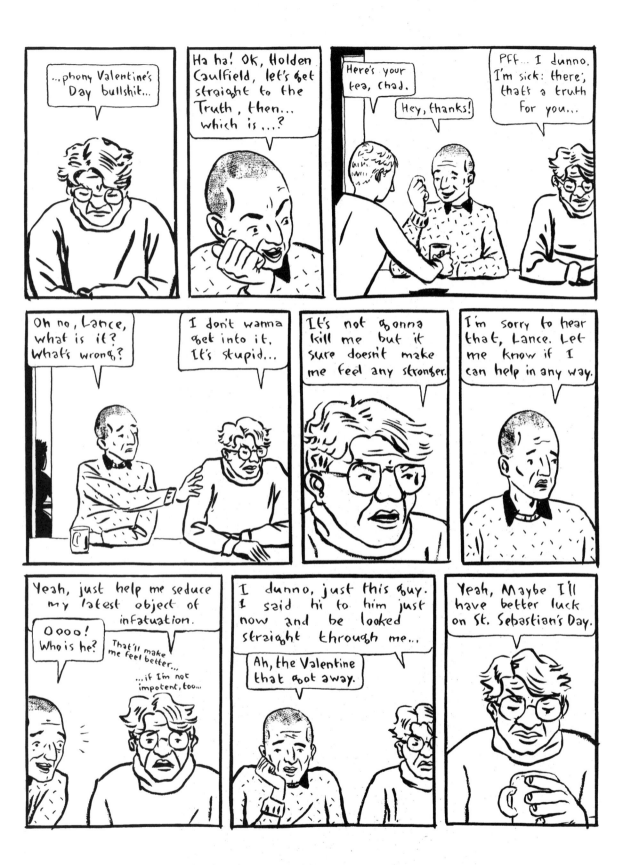

3.

FEBRUARY 15

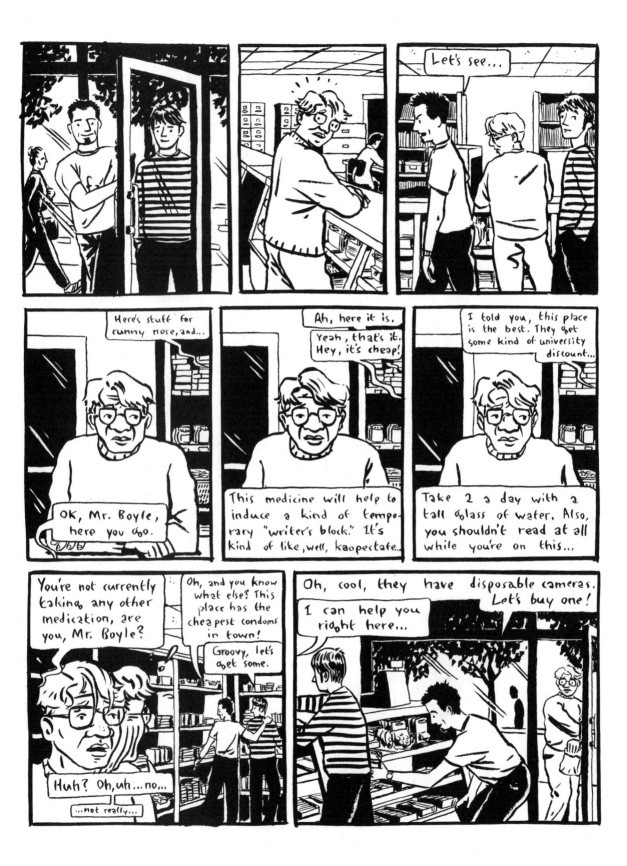

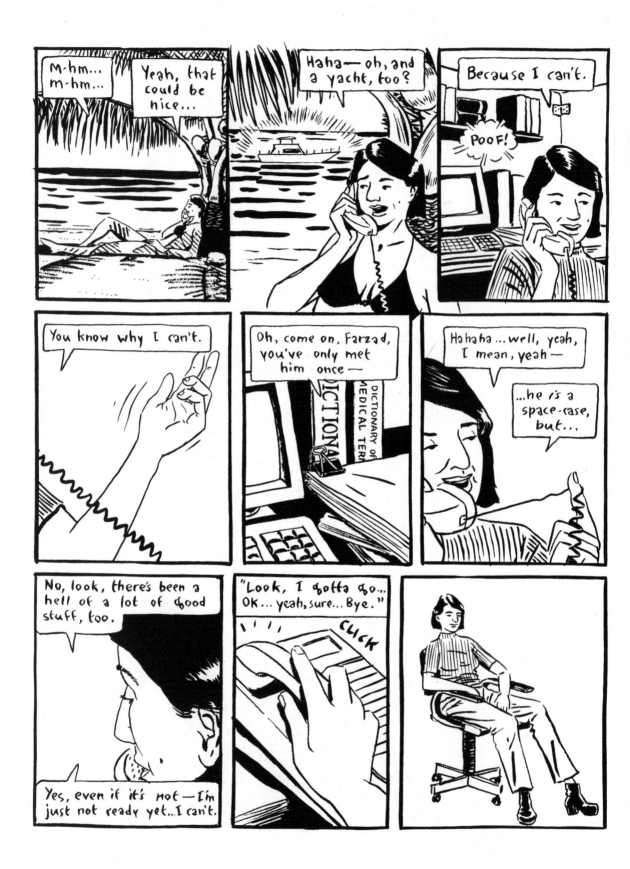

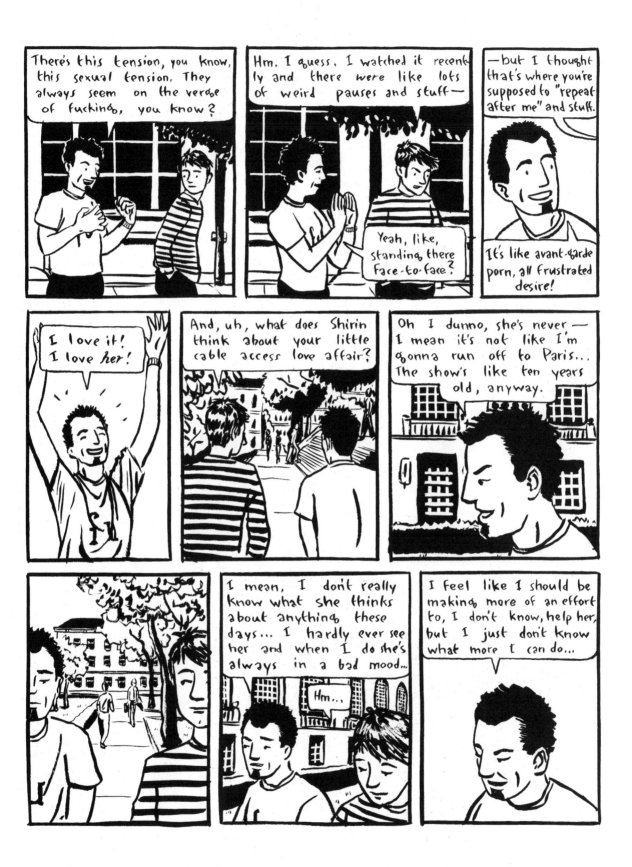

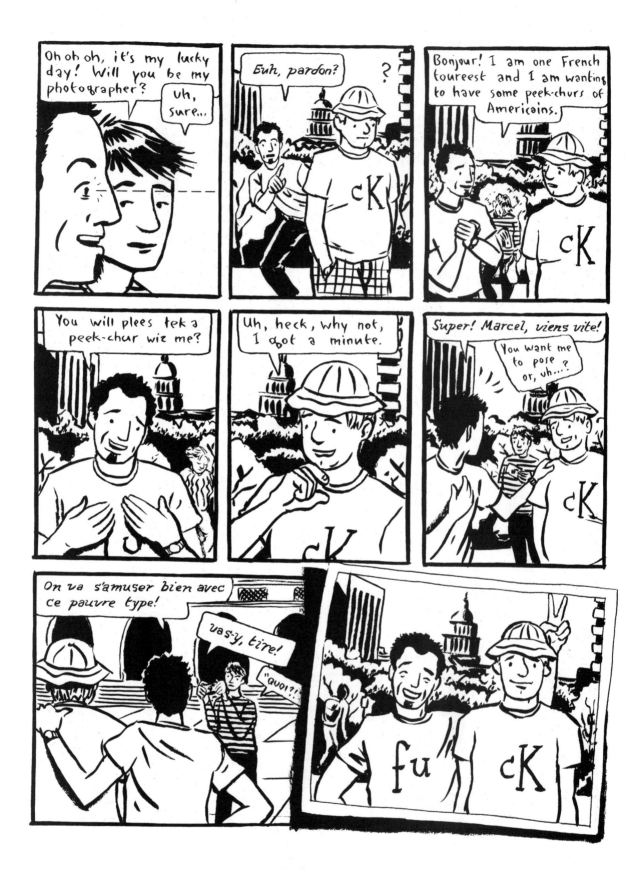

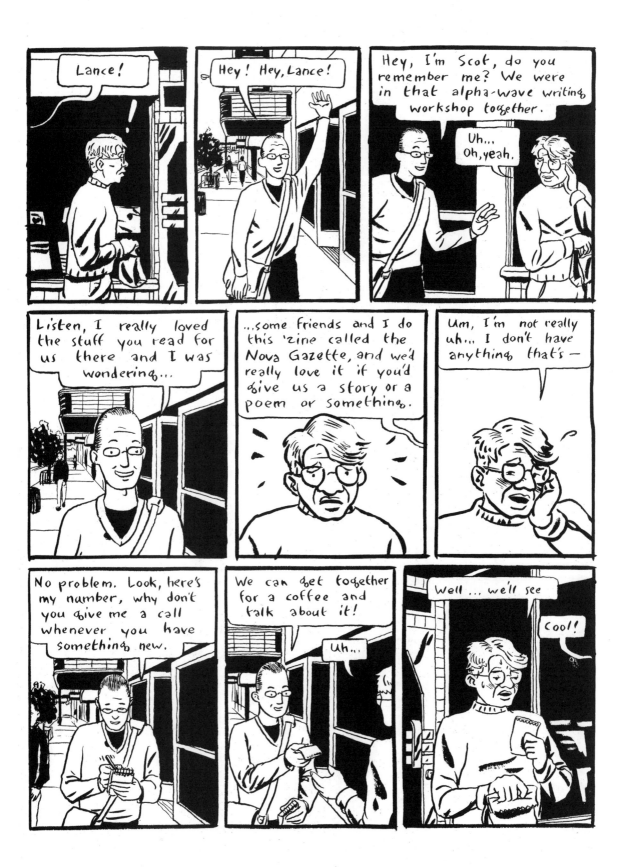

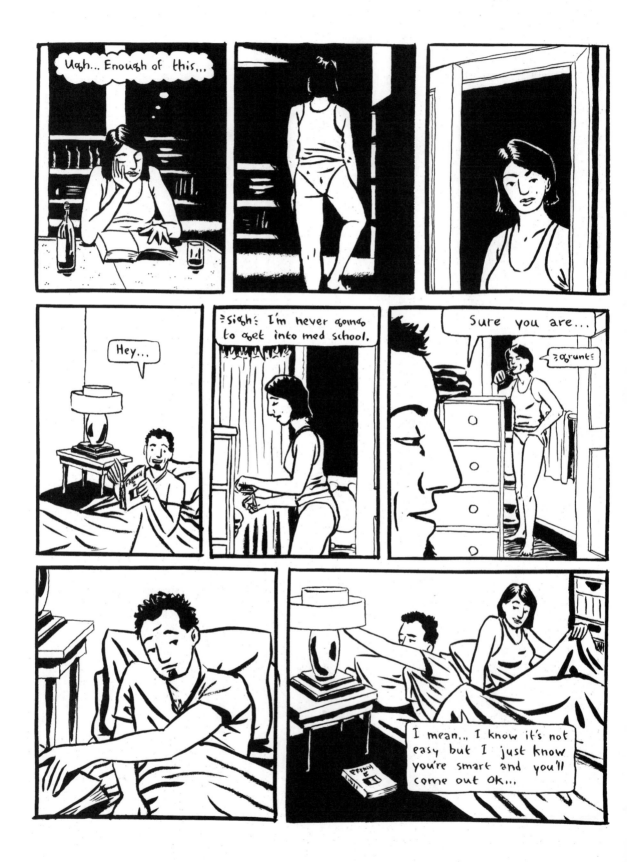

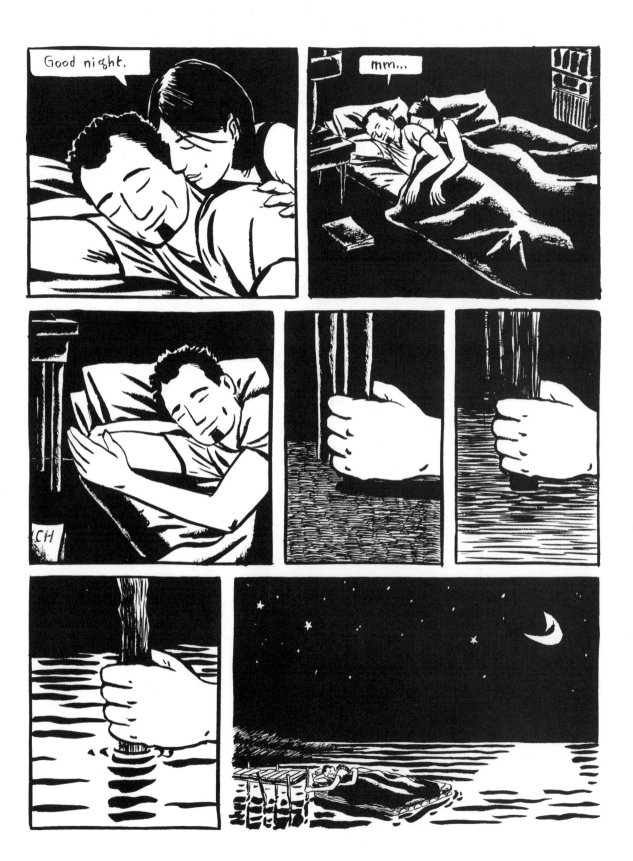

4.

MARCH 17

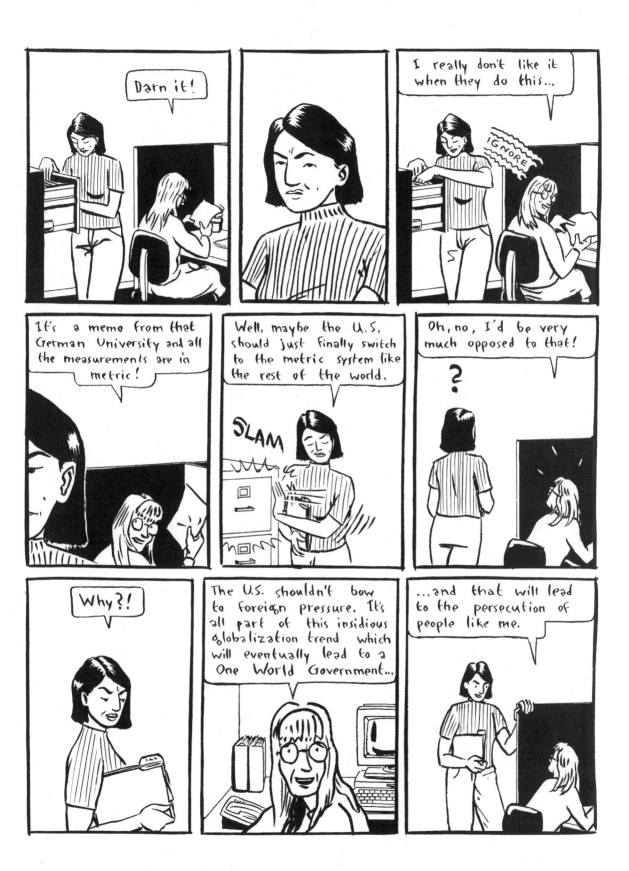

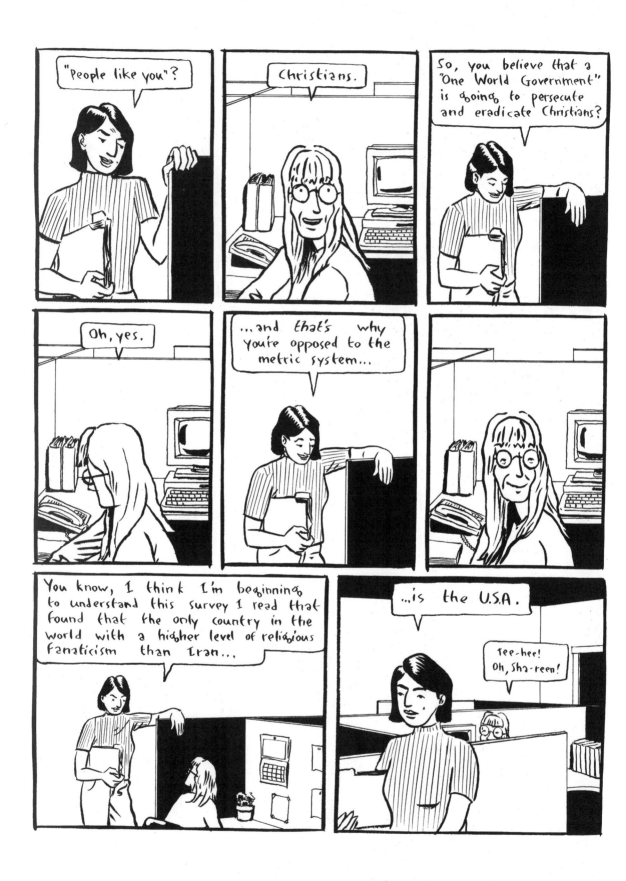

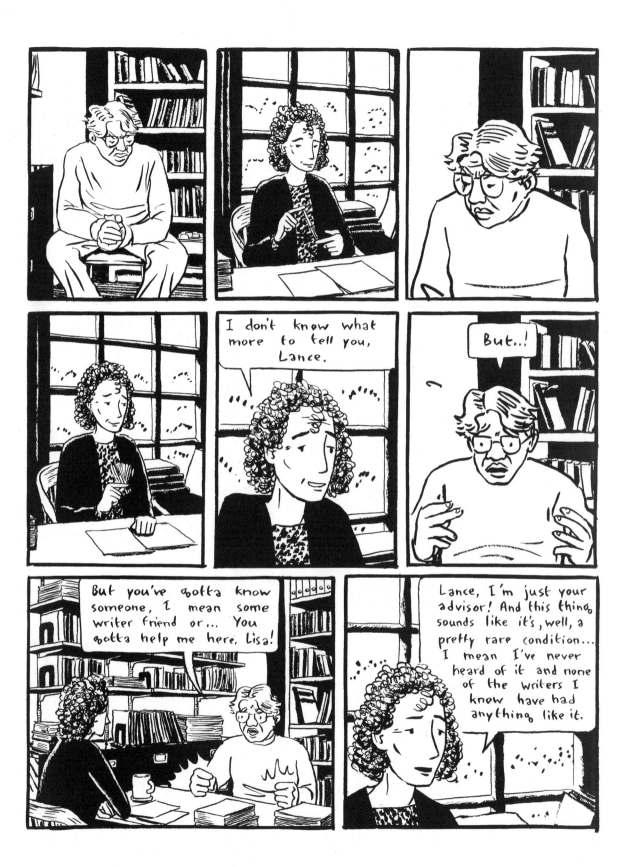

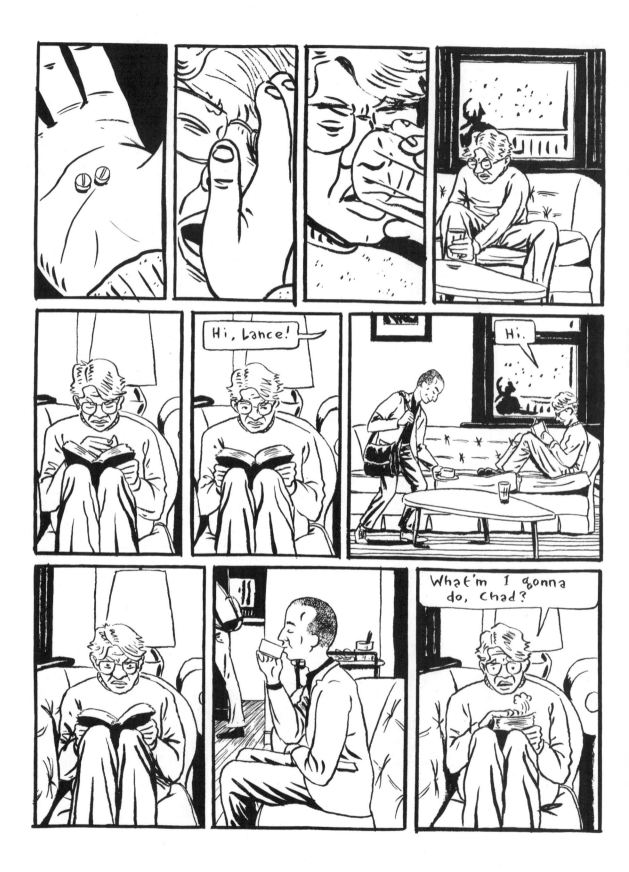

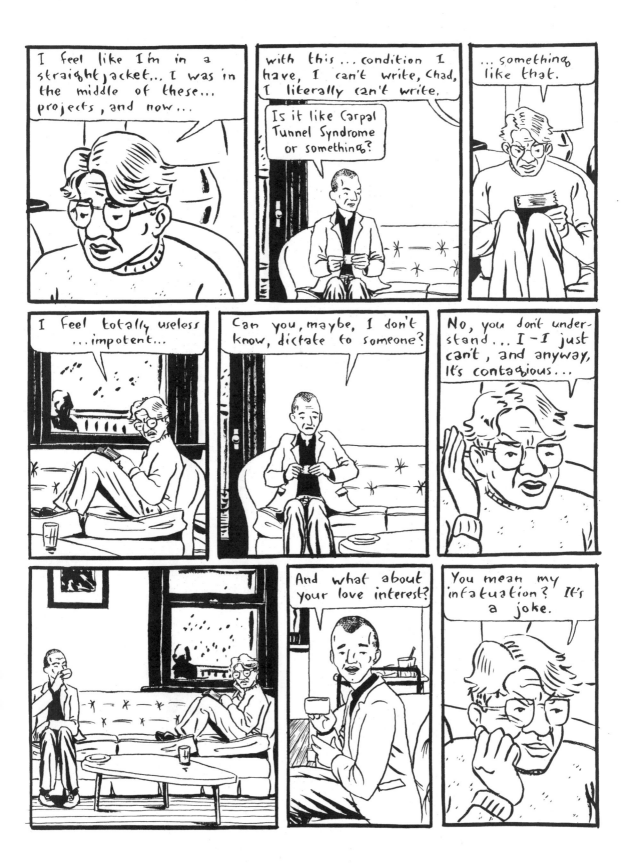

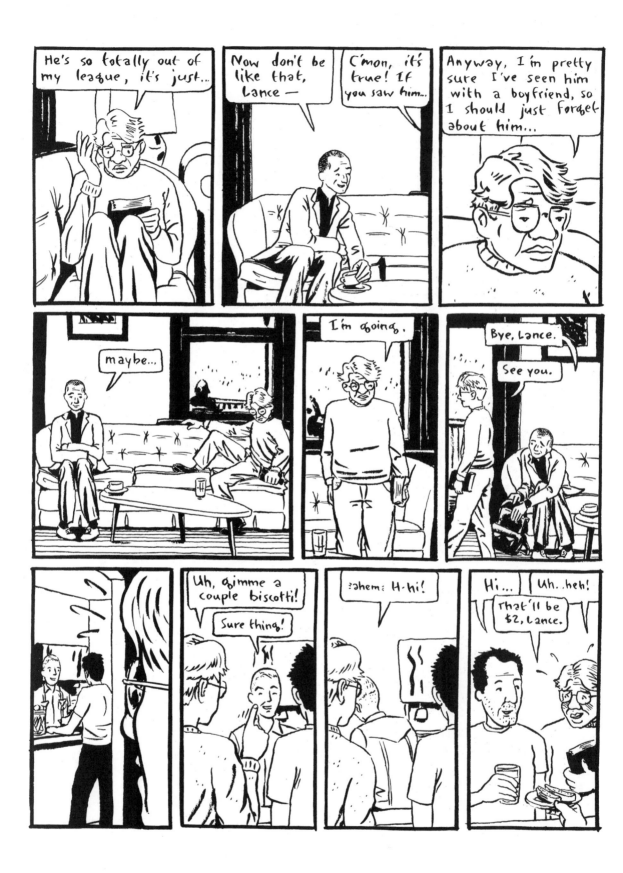

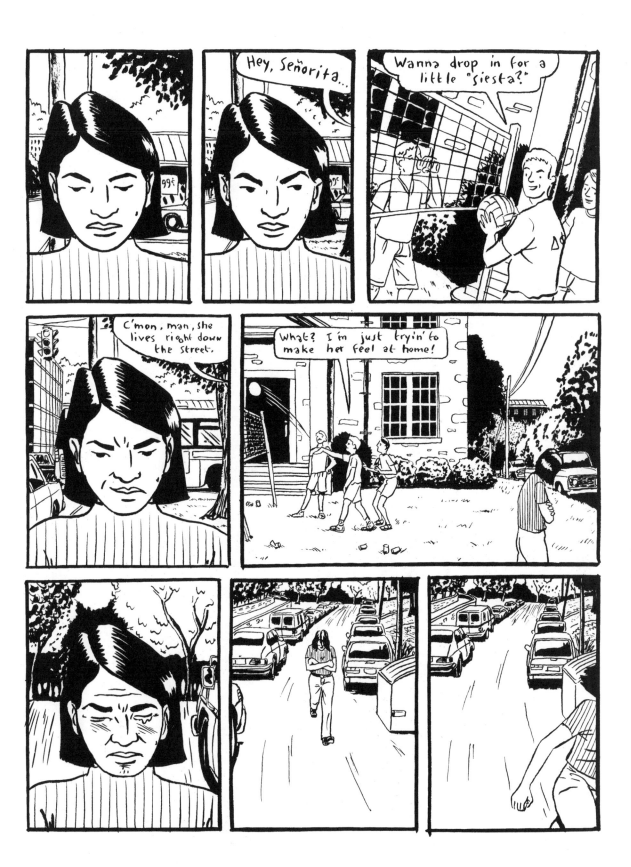

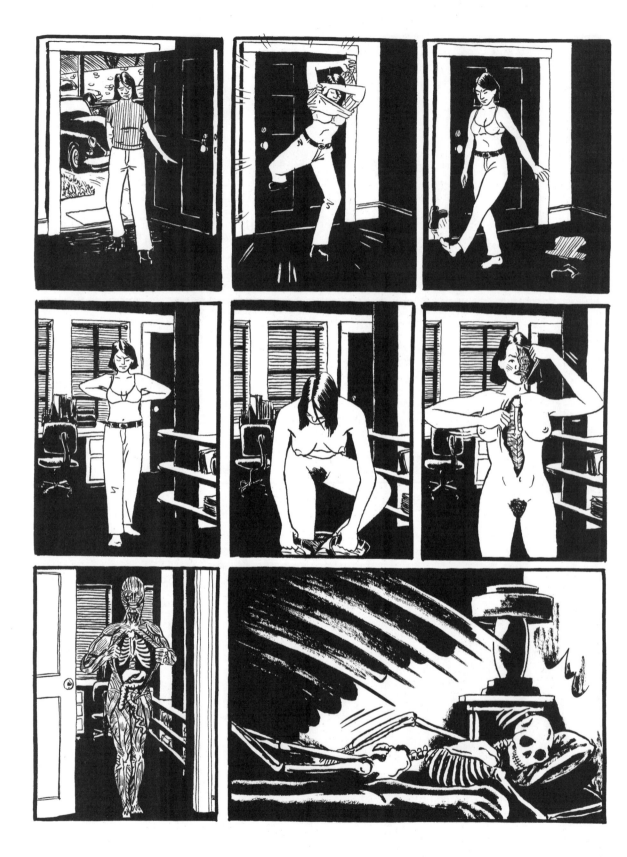

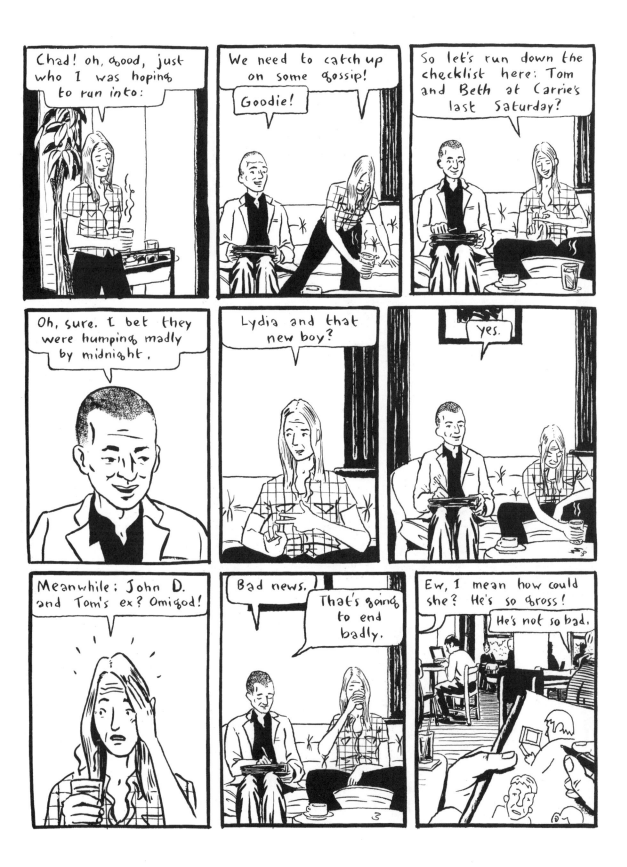

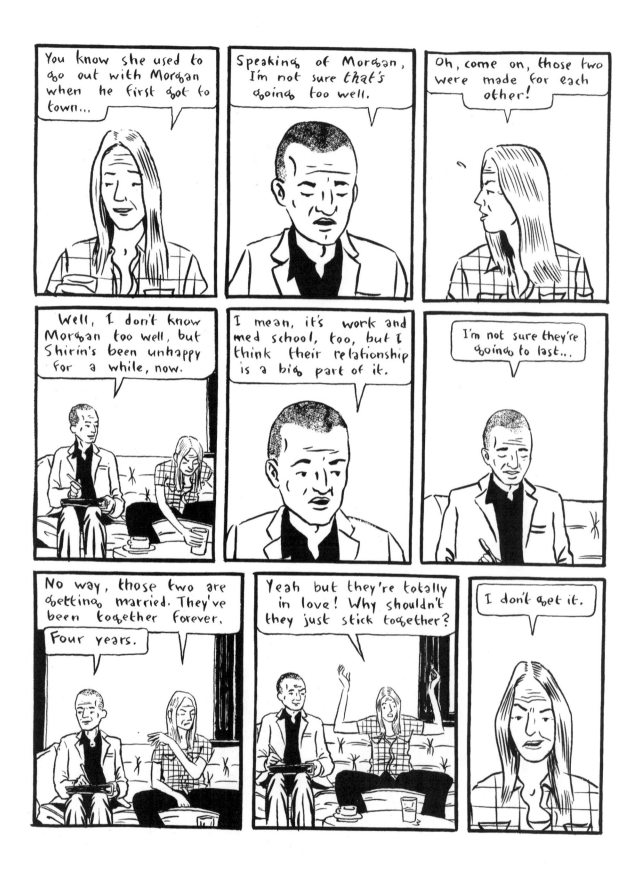

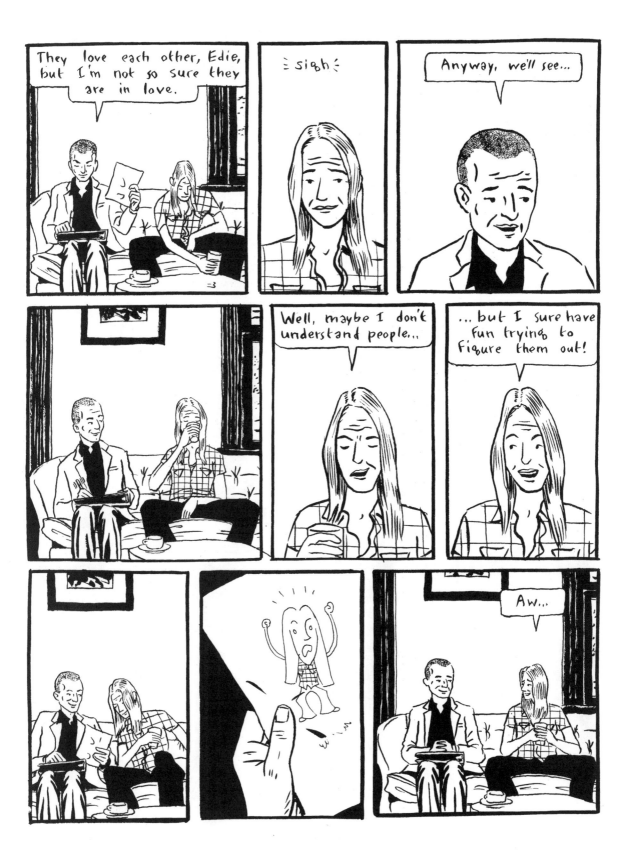

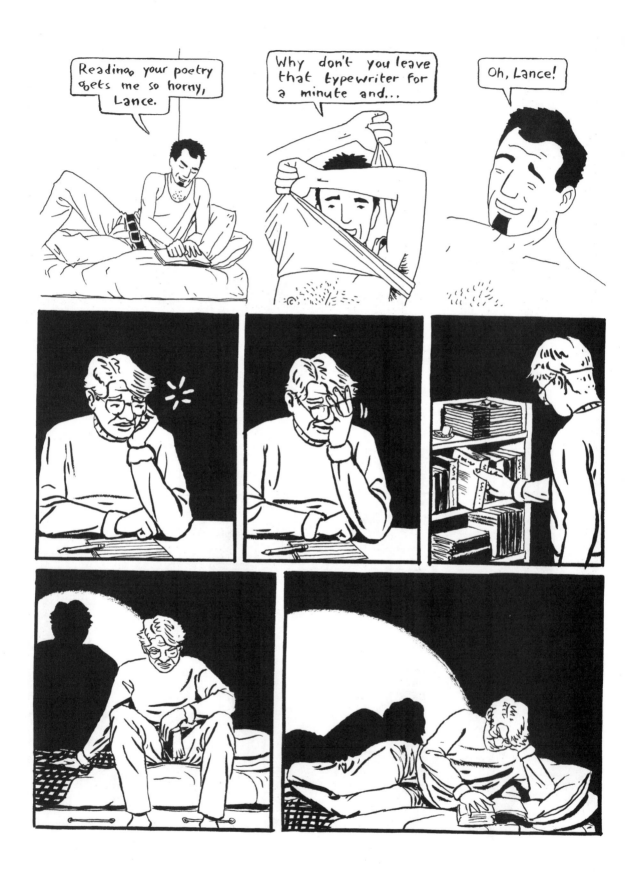

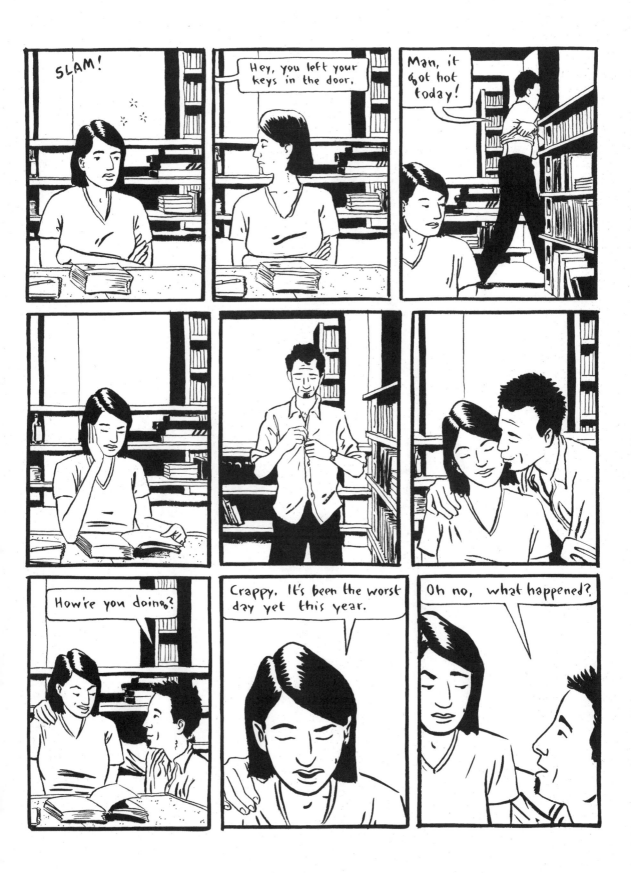

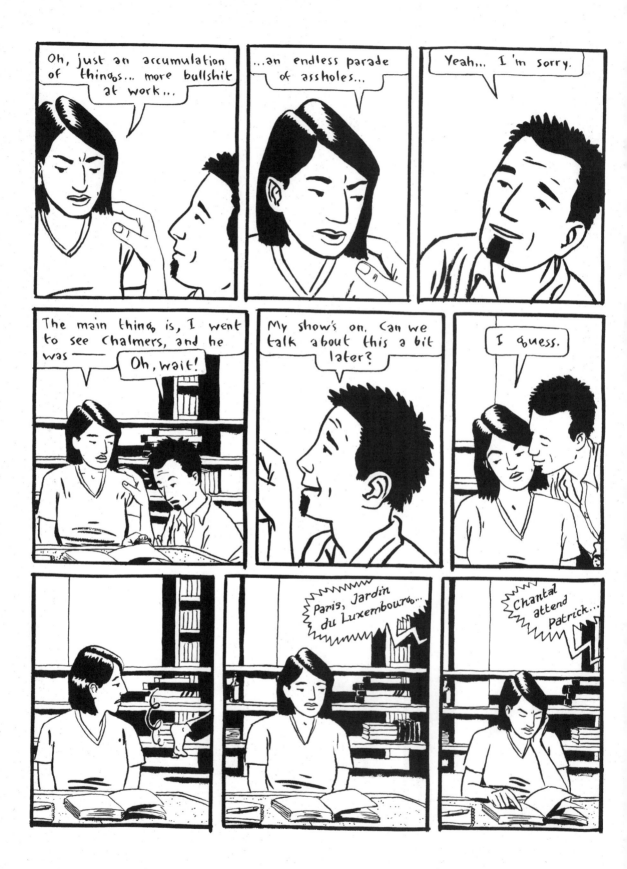

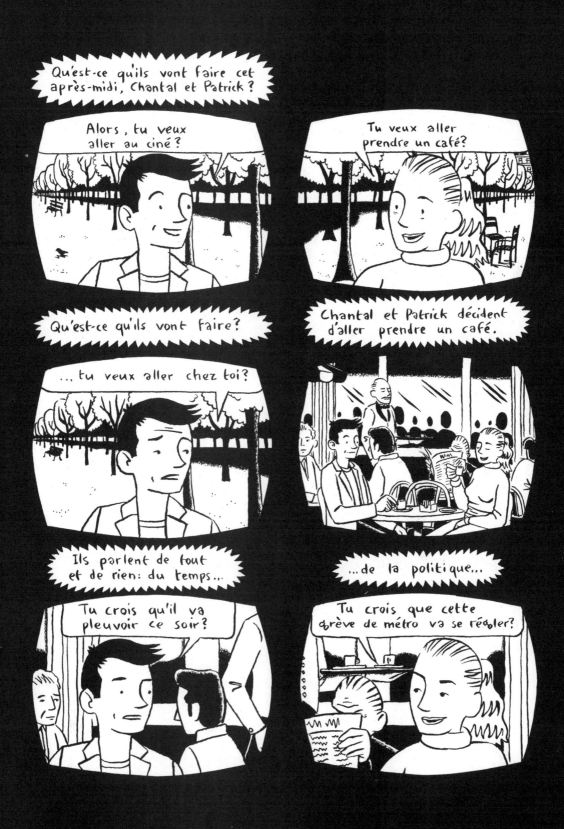

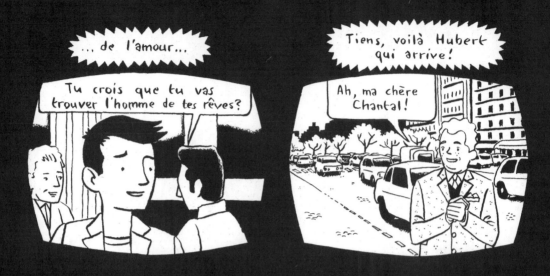

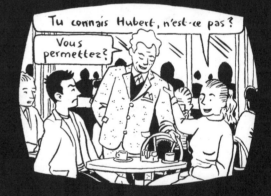

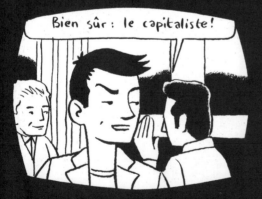

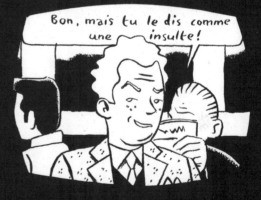

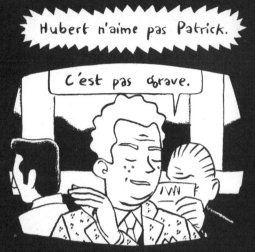

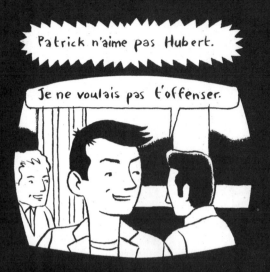

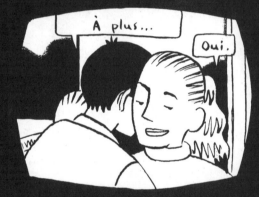

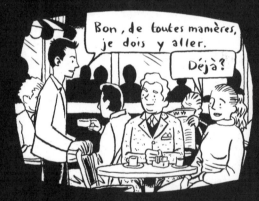

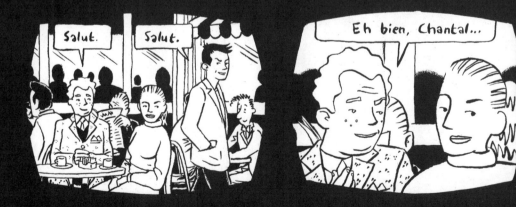

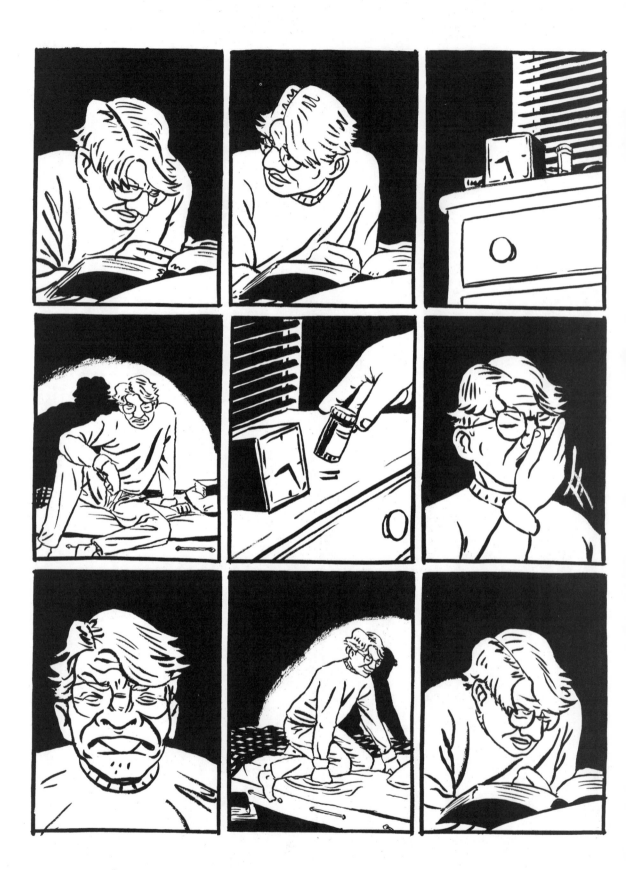

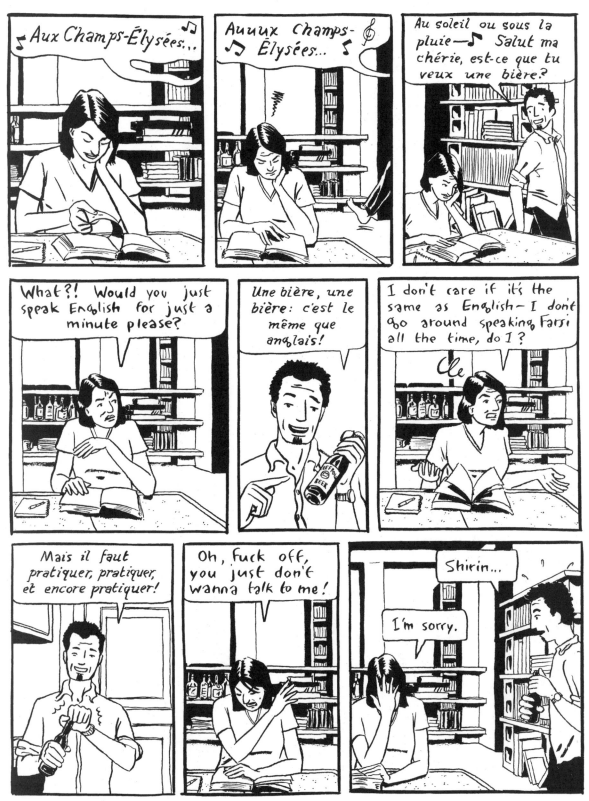

Pierre Delanoë - "Les Champs Elysées"

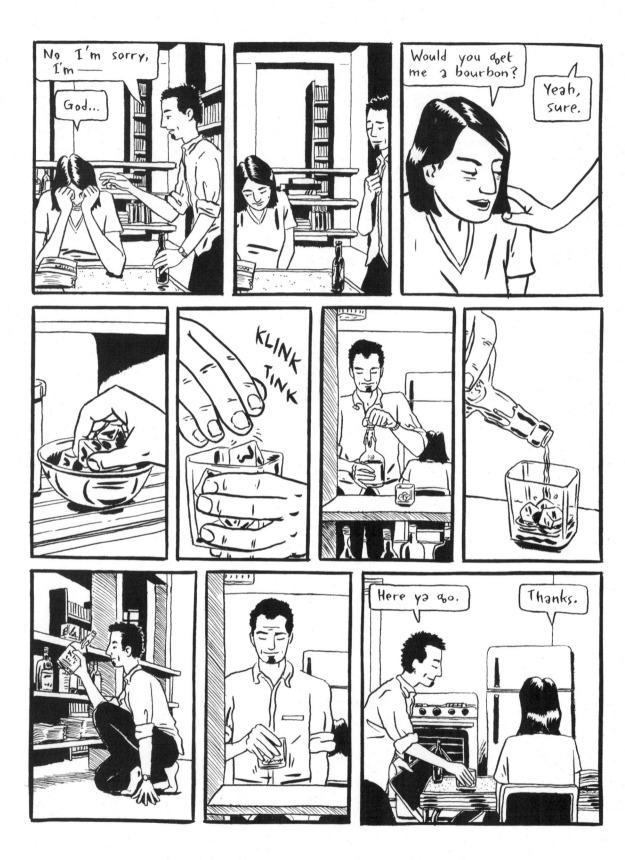

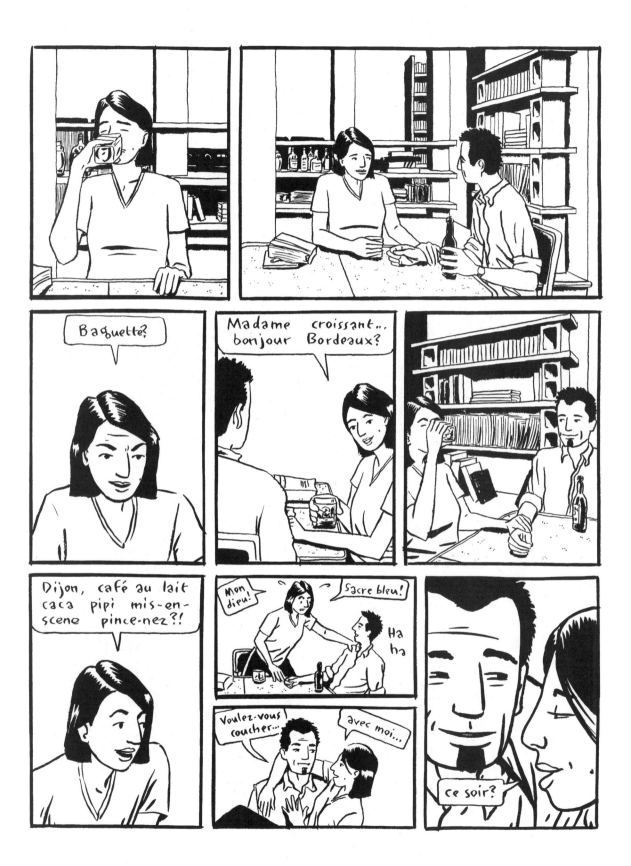

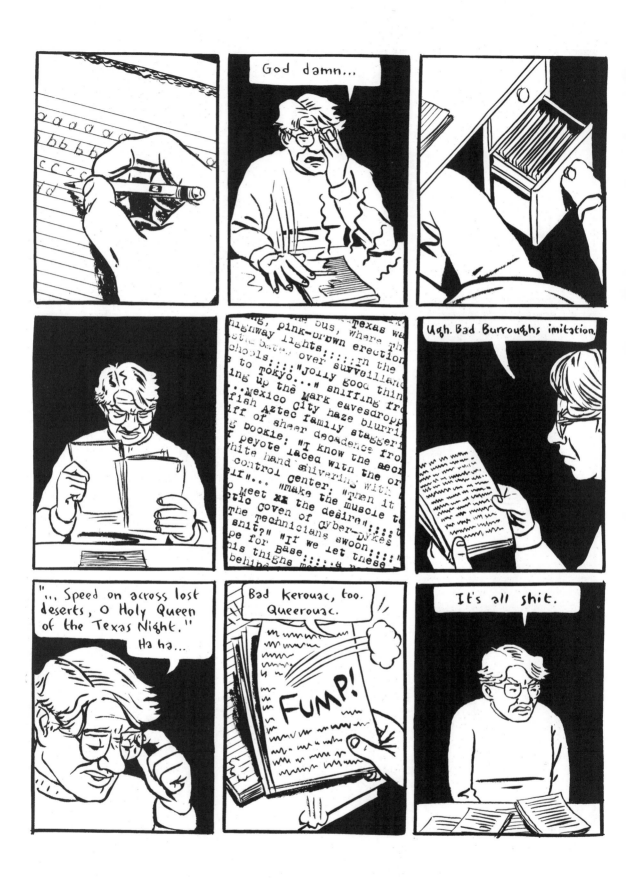

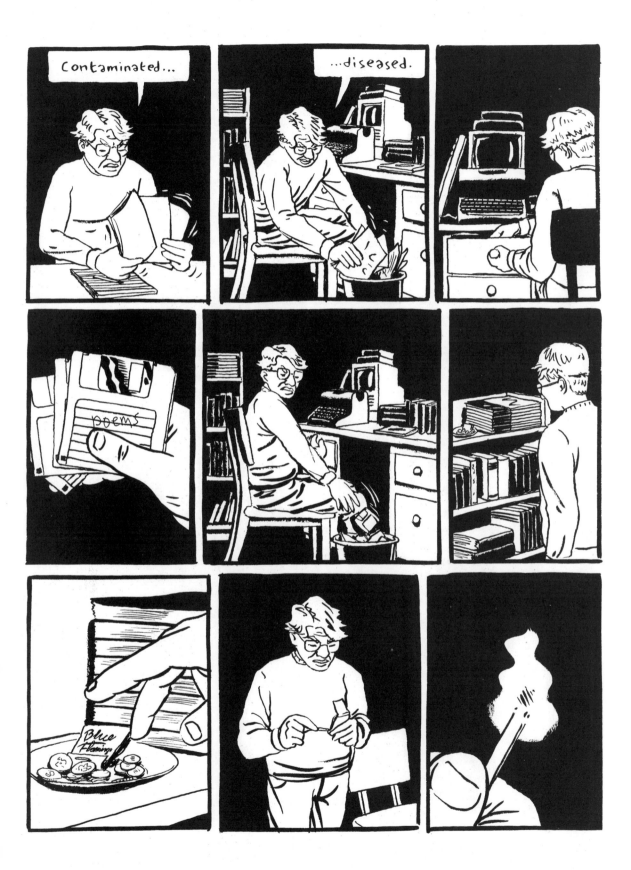

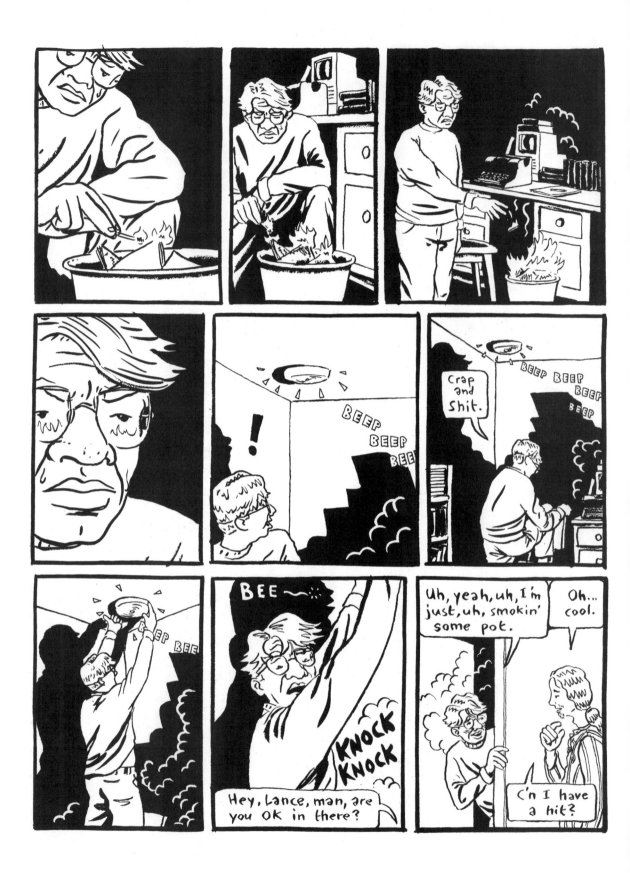

5.

MARCH 18

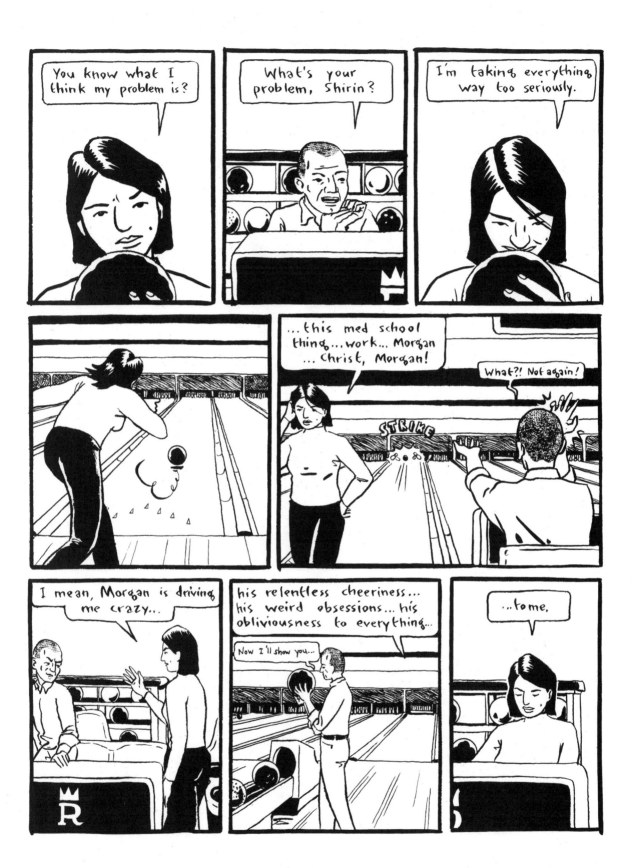

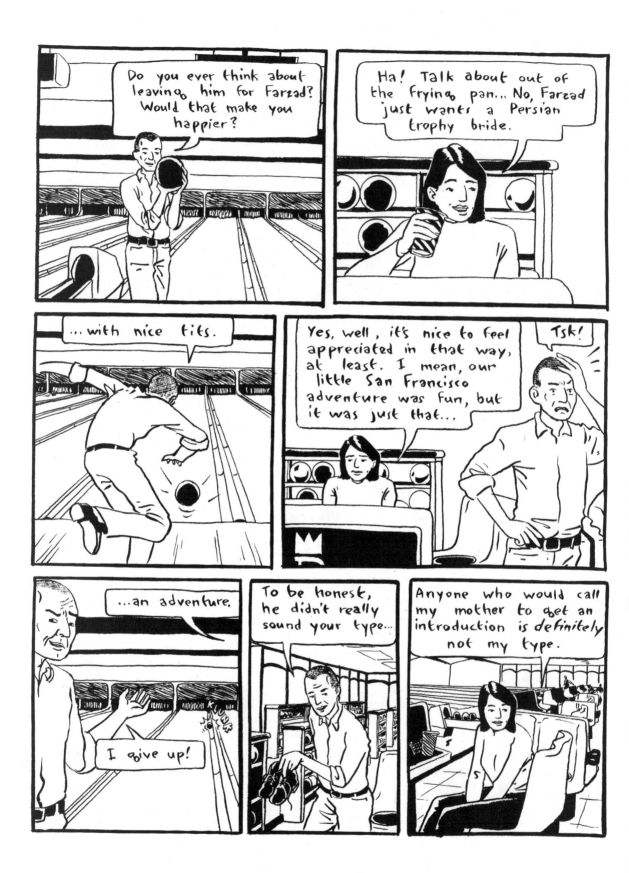

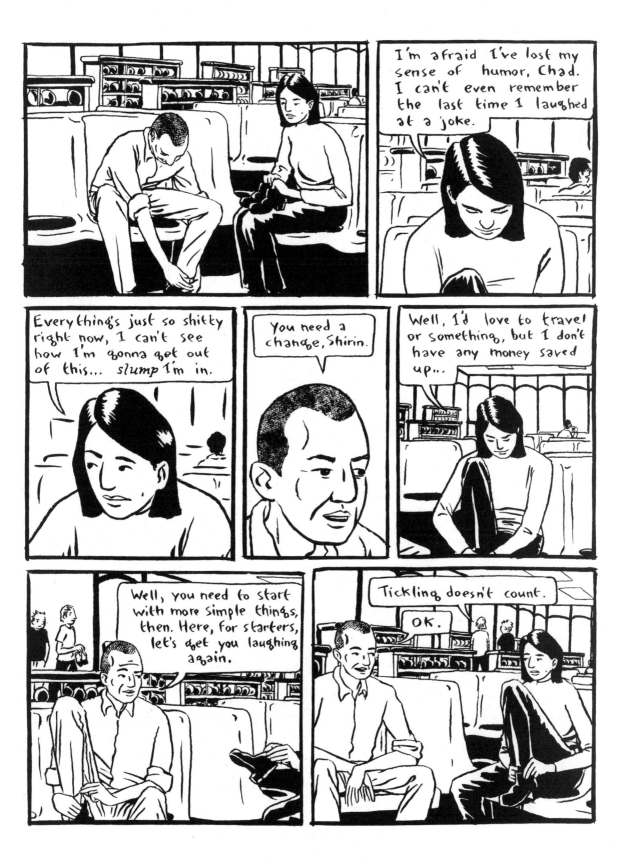

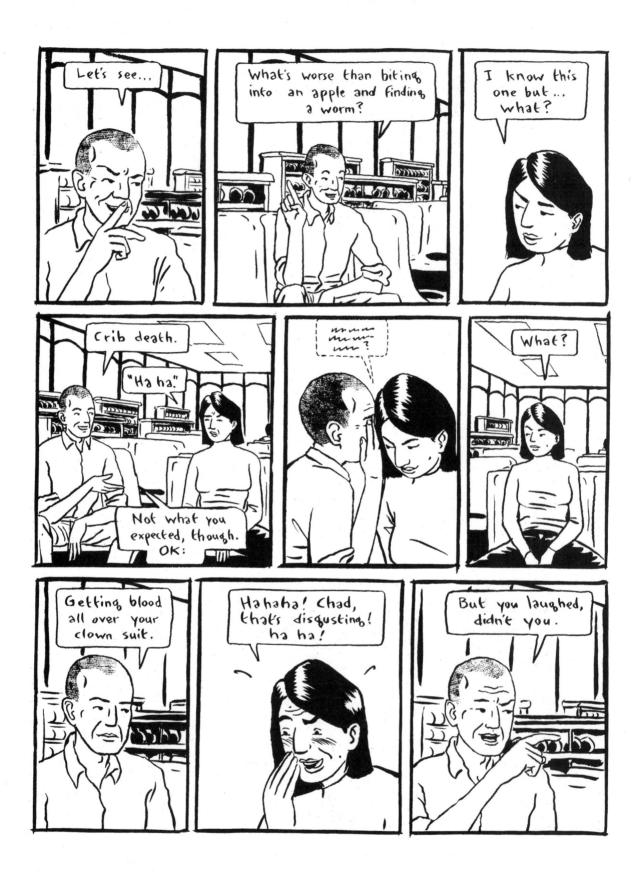

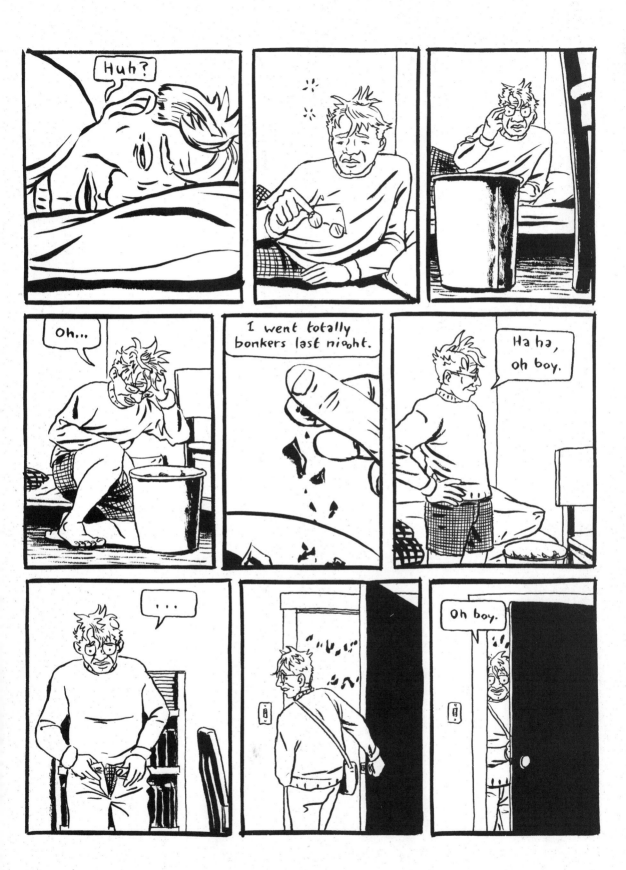

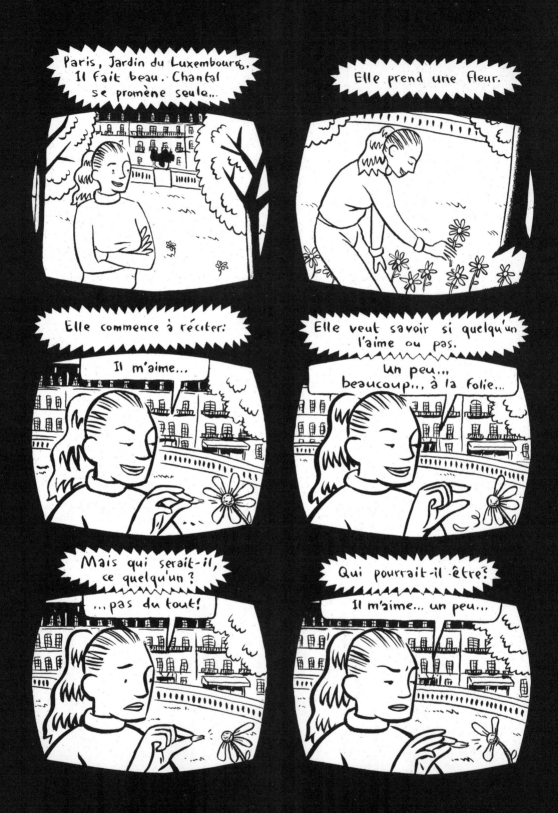

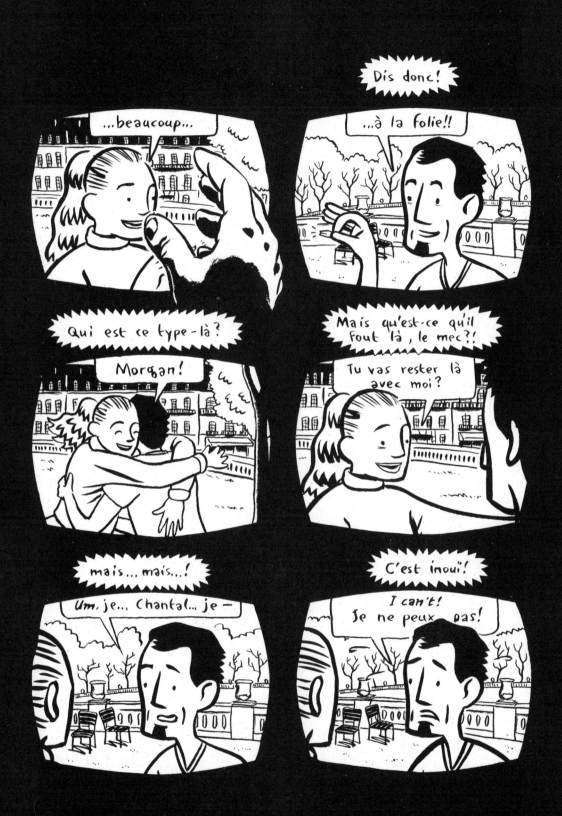

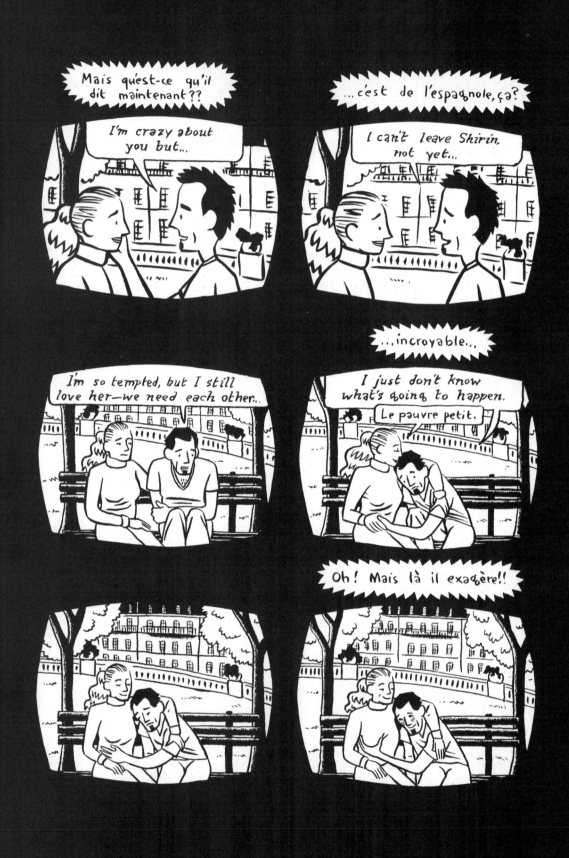

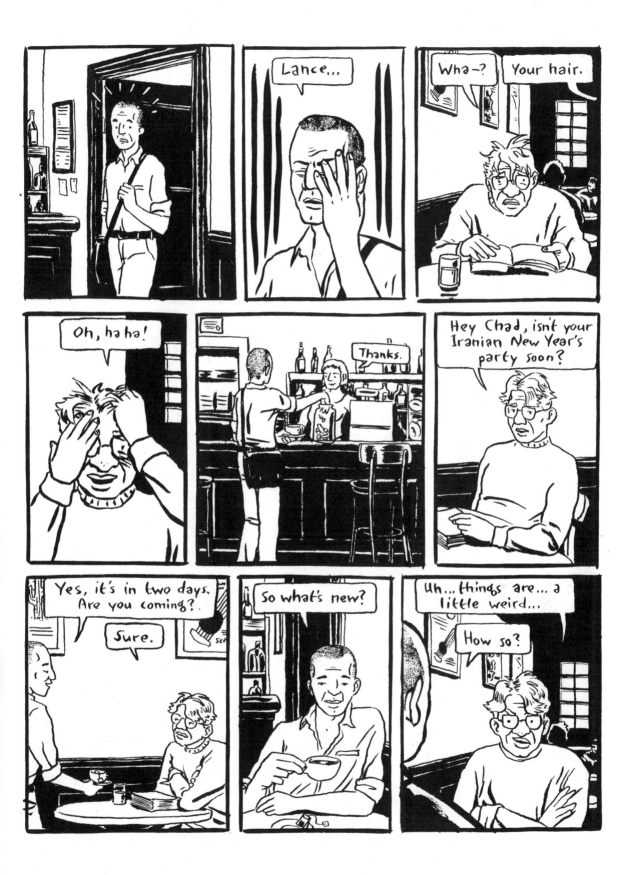

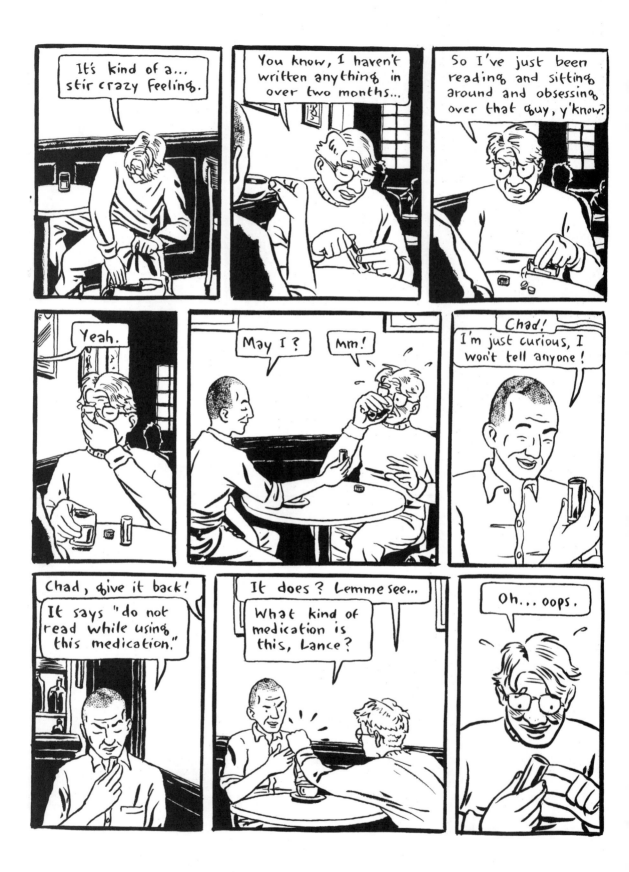

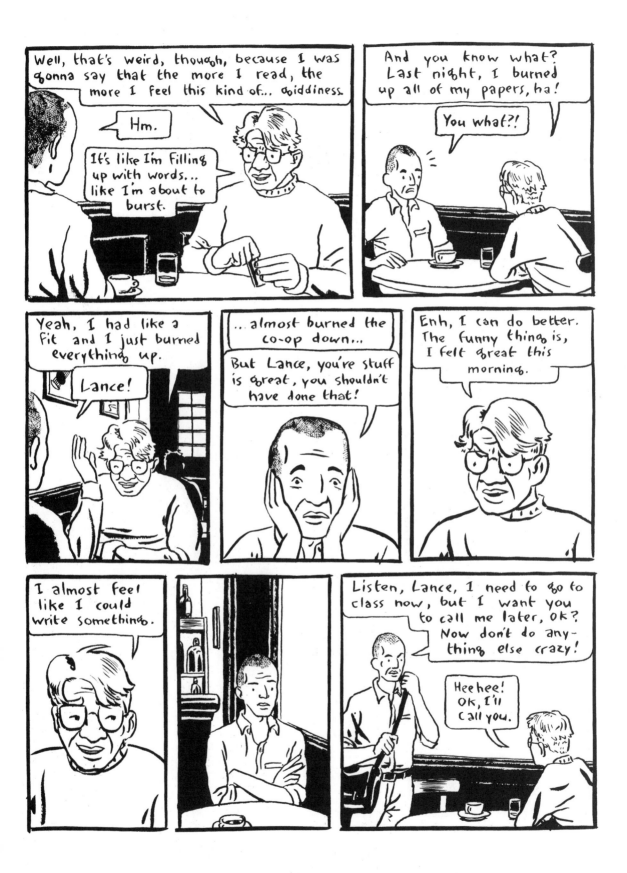

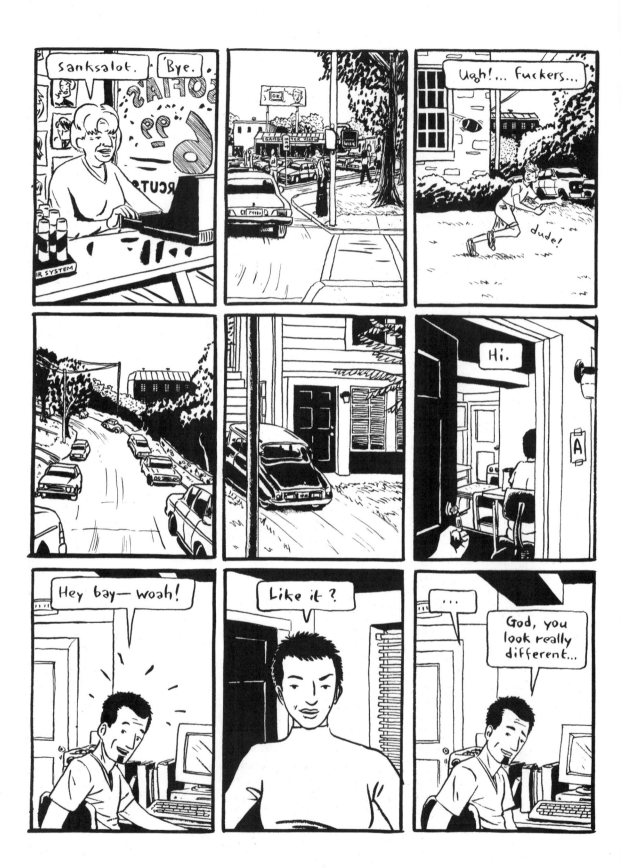

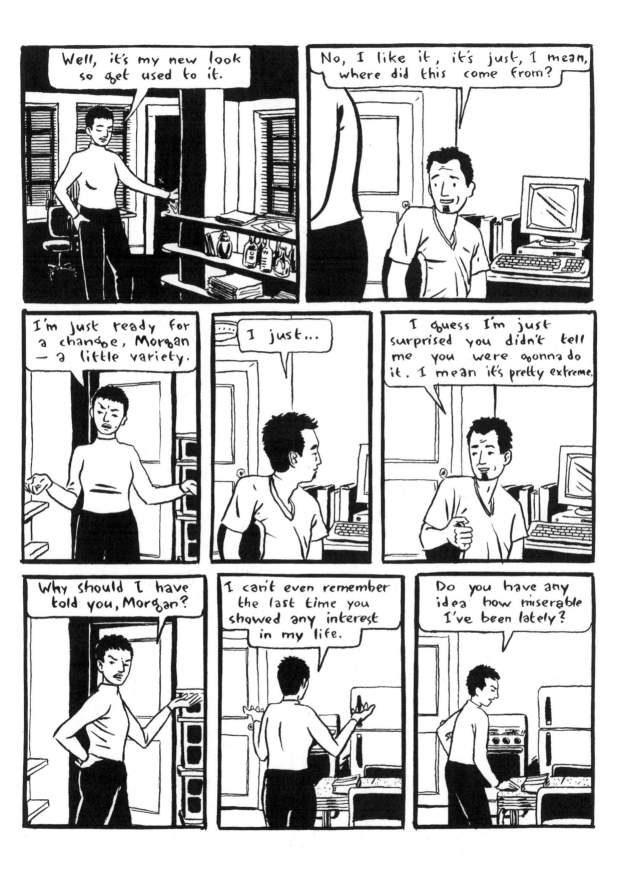

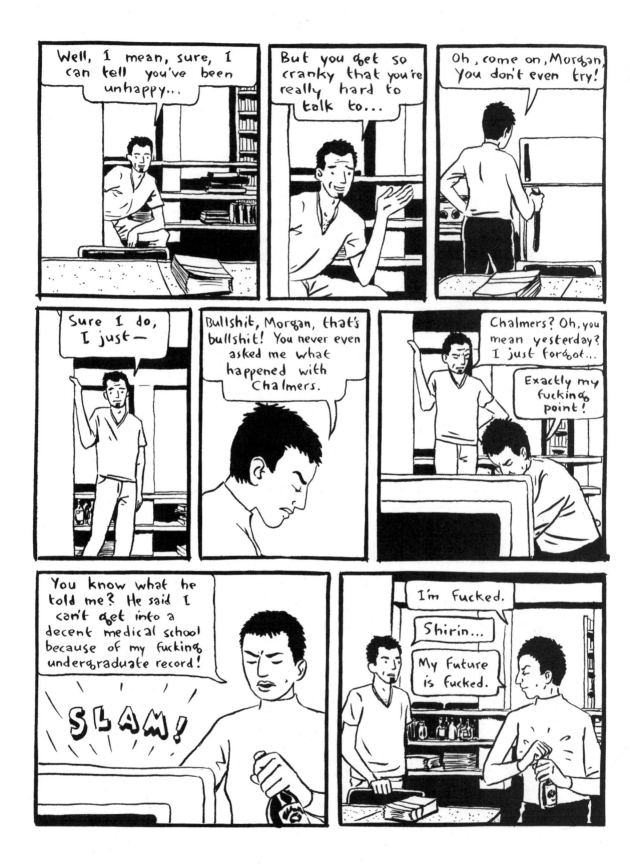

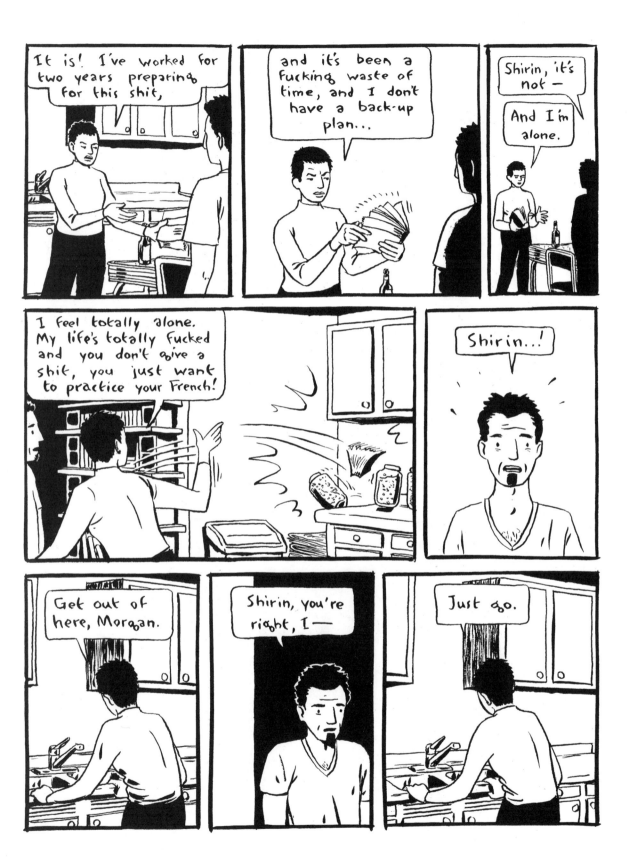

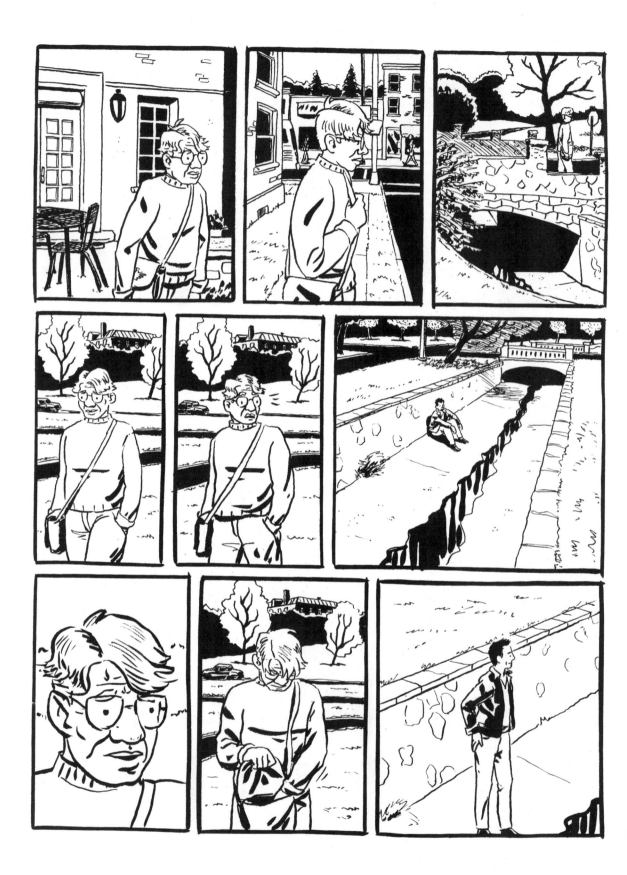

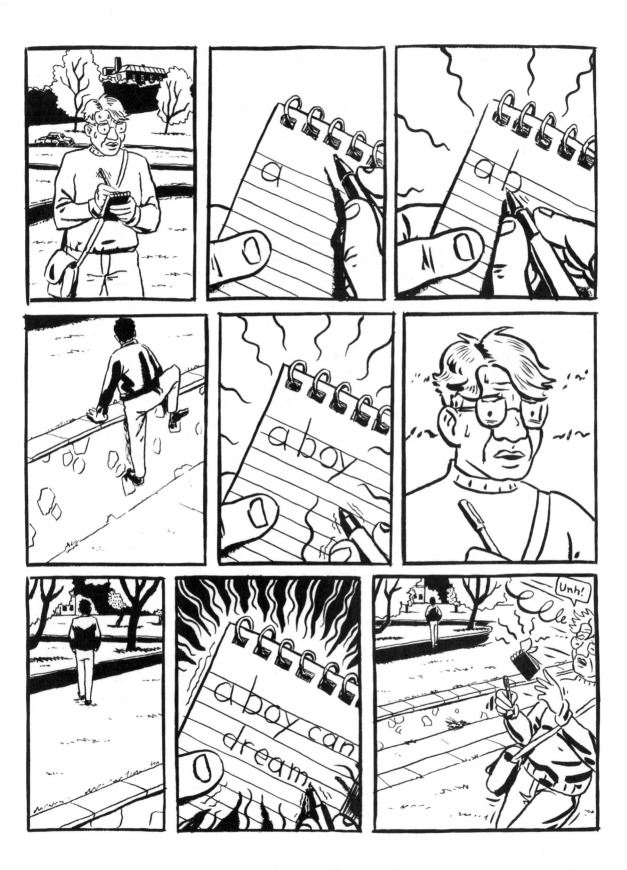

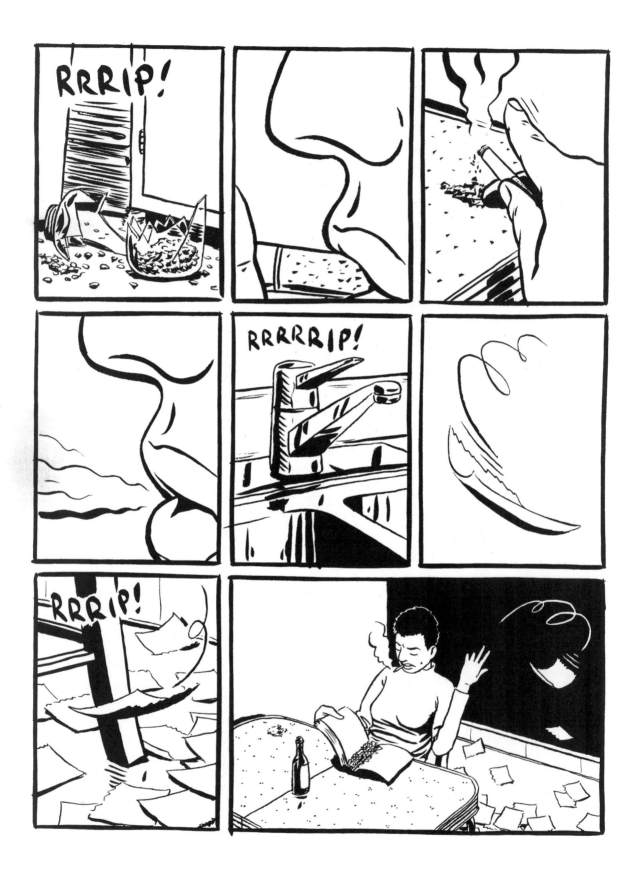

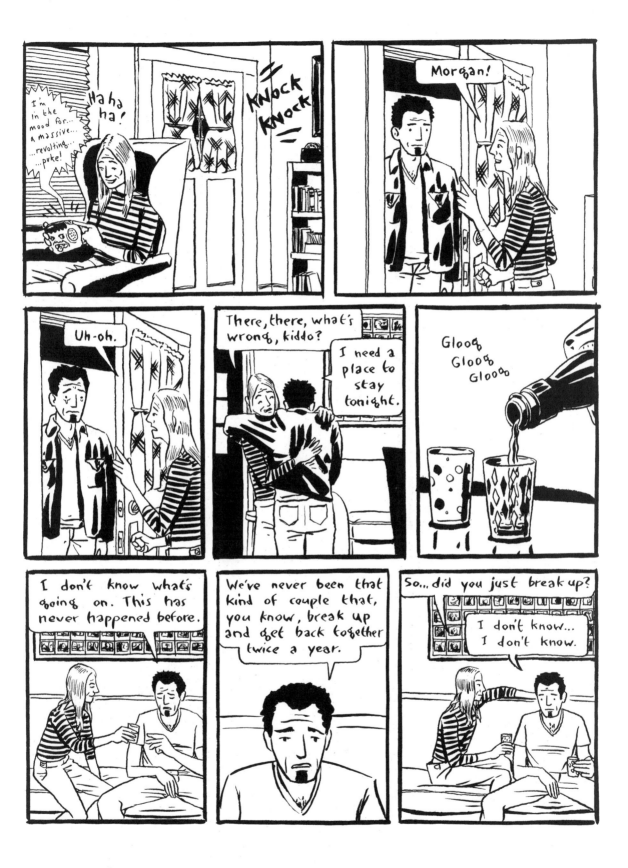

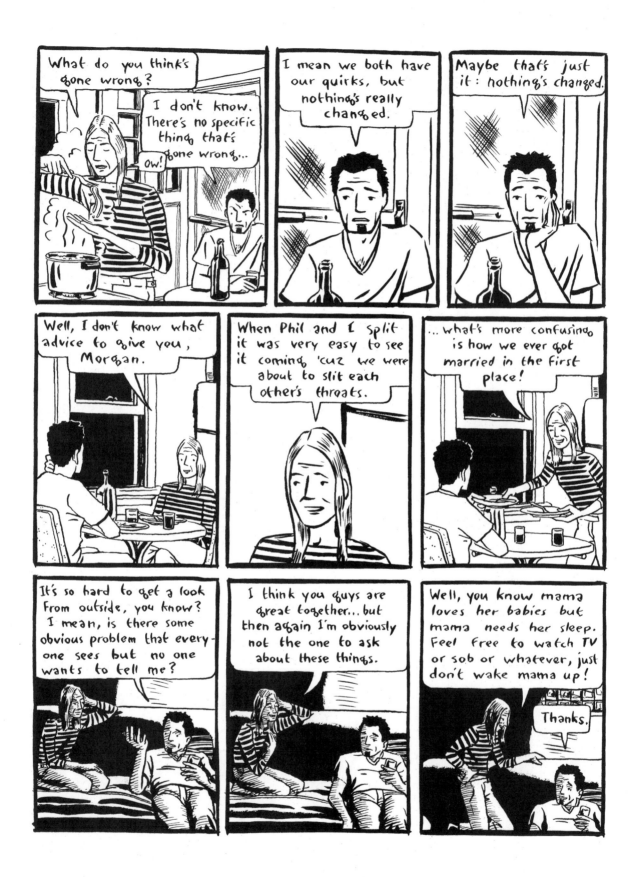

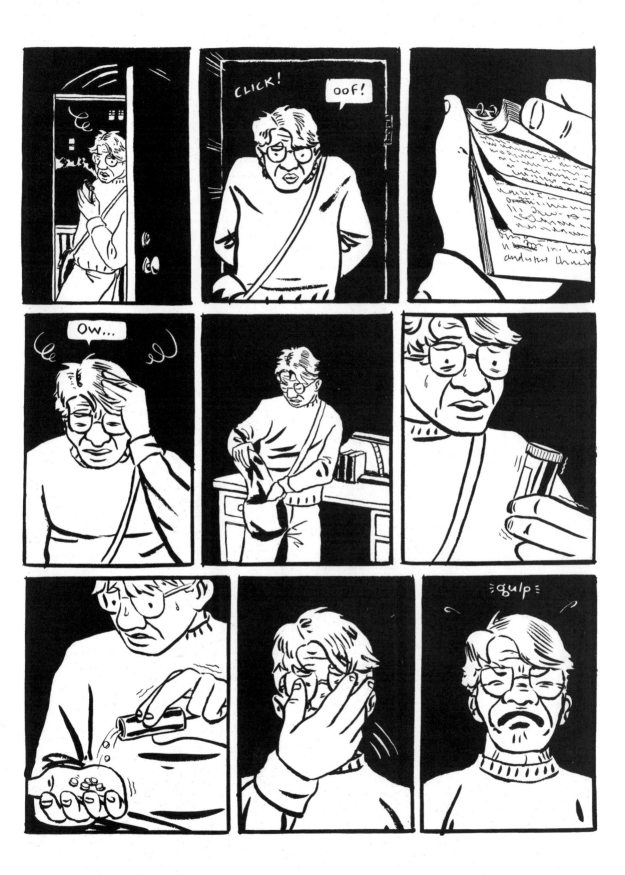

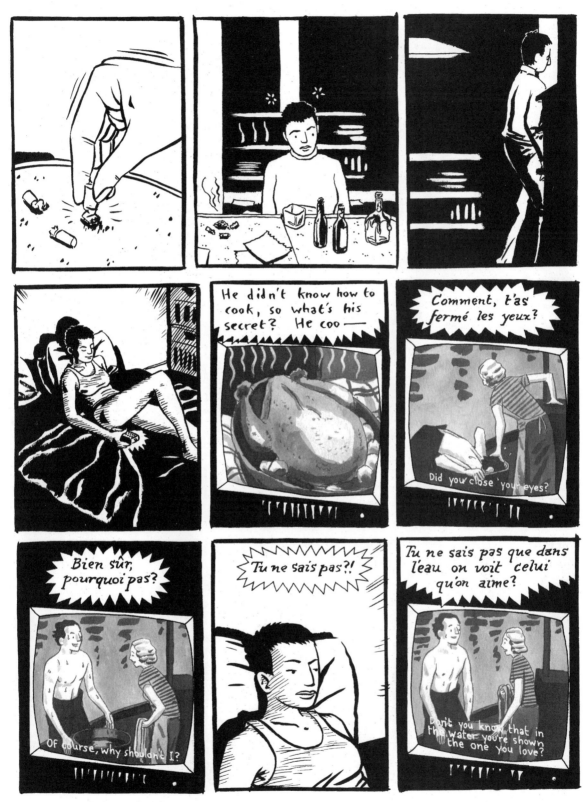

Jean Vigo — "L'Atalante" (1934)

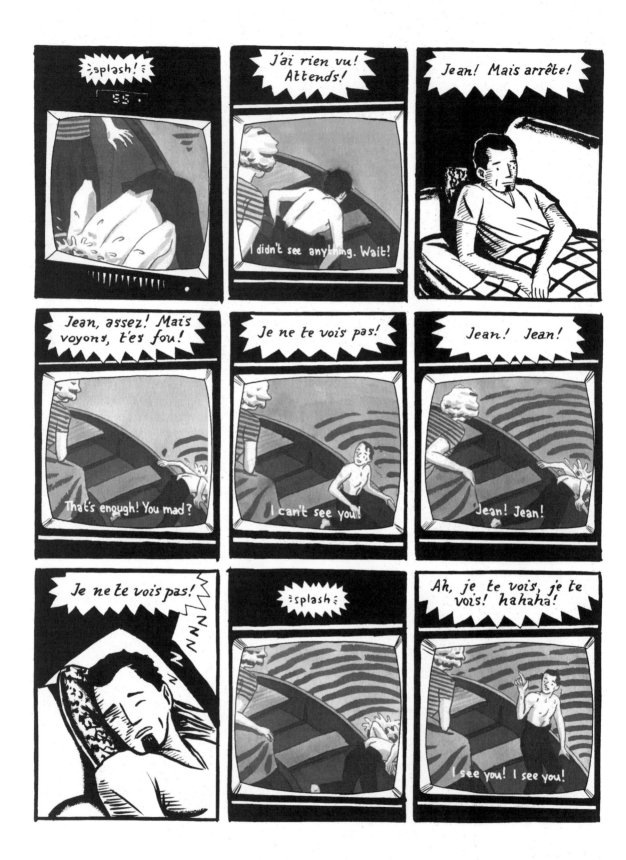

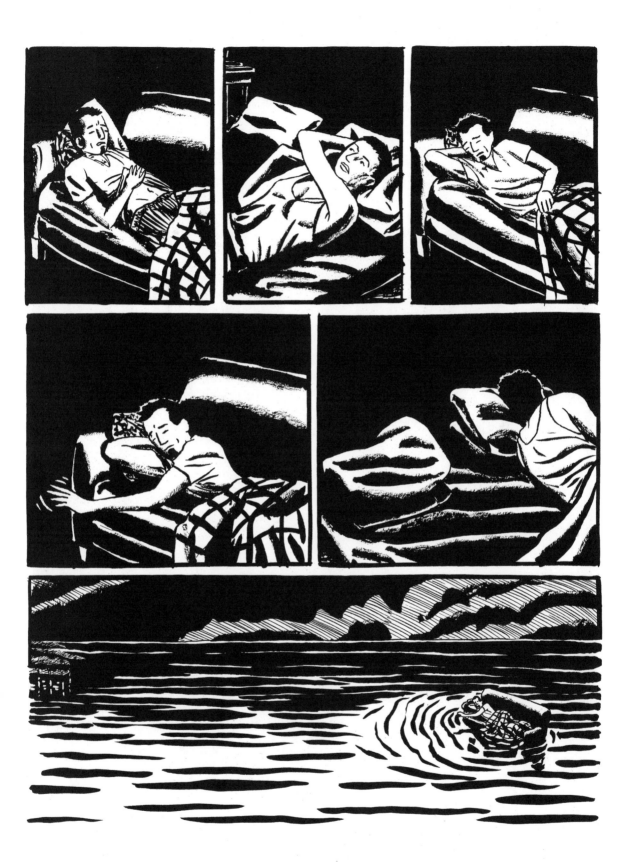

6.

MARCH 19

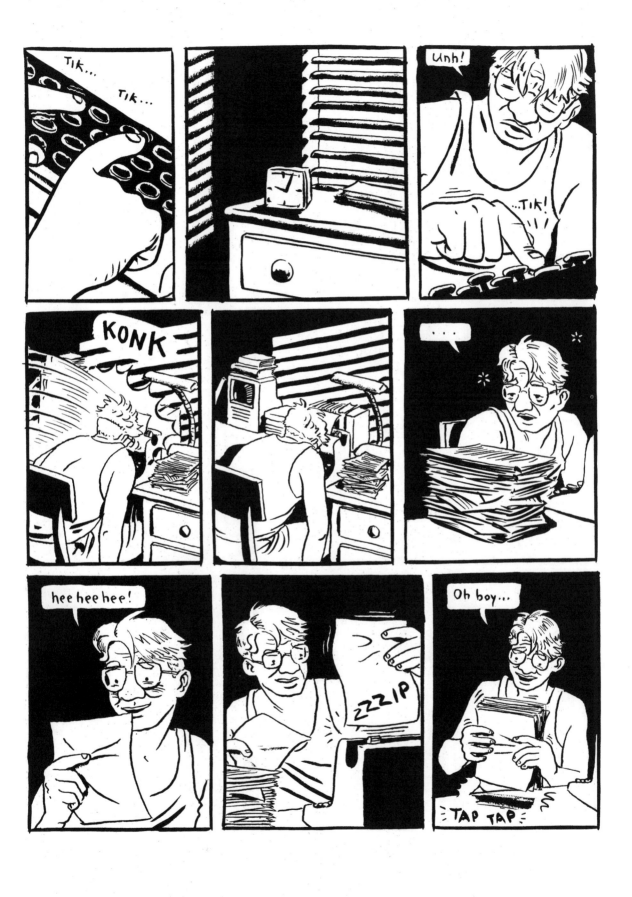

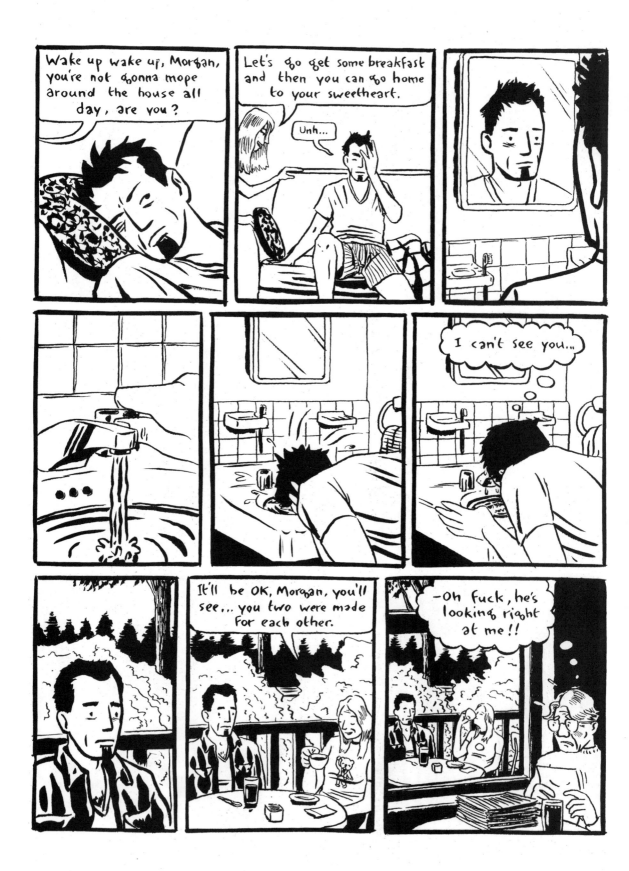

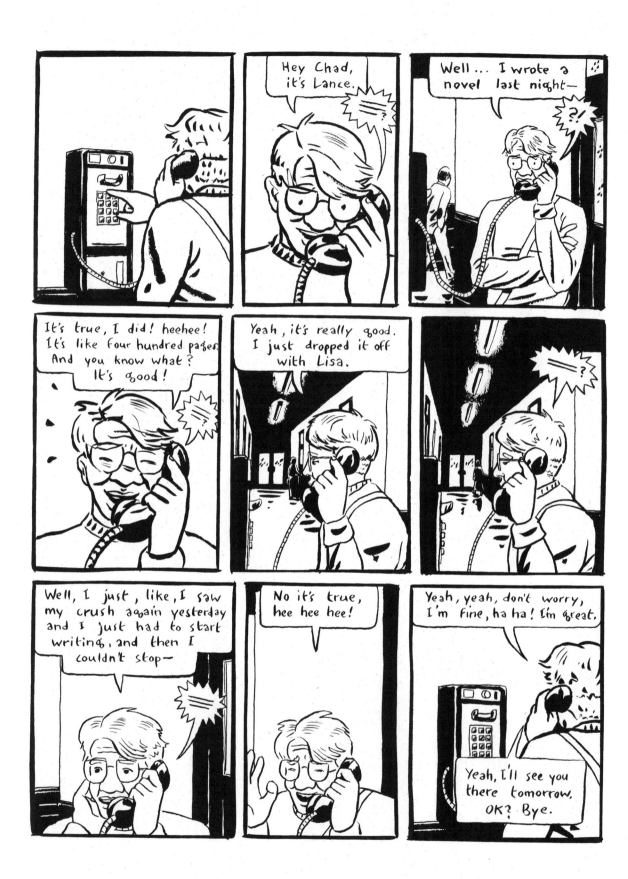

7.

MARCH 20

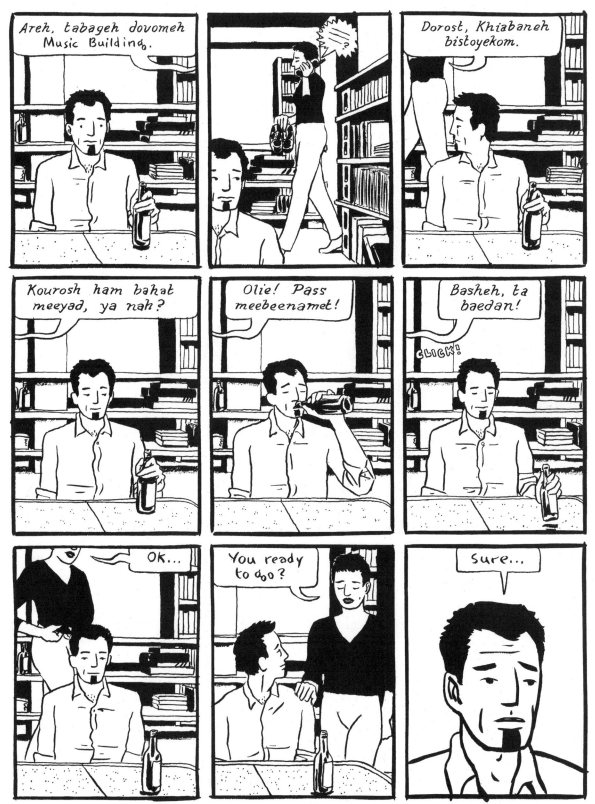

Panel 1: Yeah, it's in the Music building, on the second floor. Panel 3: Right, on 21st Street. Panel 4: Is Kourosh coming with you? Panel 5: Great! I can't wait to see you! Panel 6: OK, see you later!

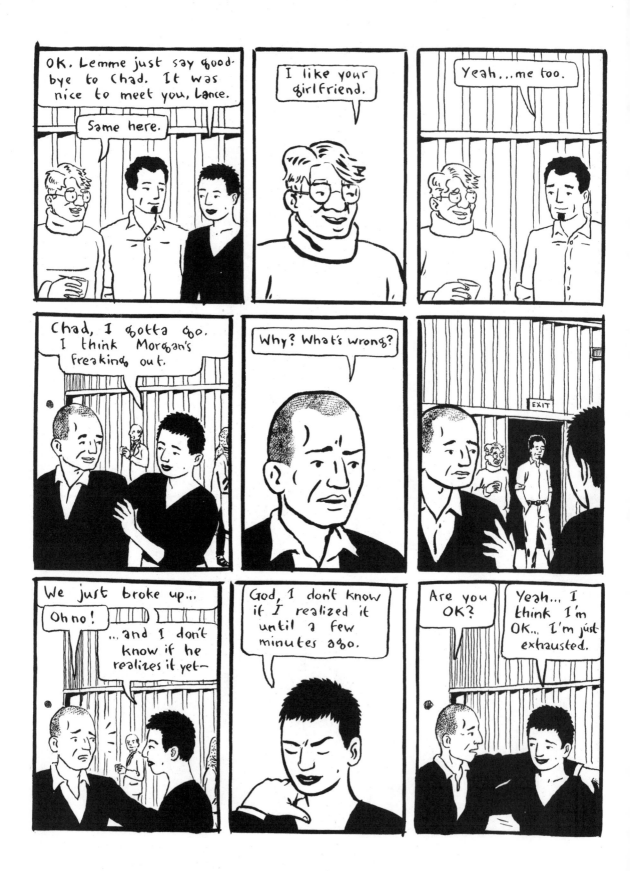

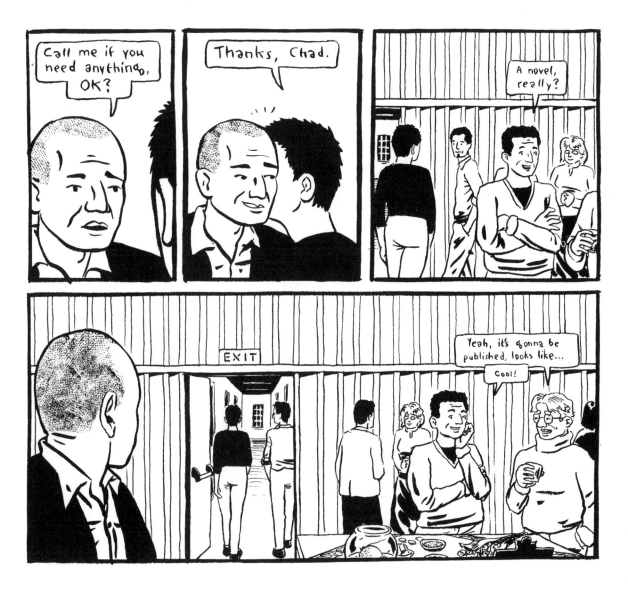

END

Lesson 15

Part I (see textbook, p. 30)

NARRATOR: Paris, Luxembourg Garden. It's nice out. Chantal has been waiting for Patrick for some time. Patrick is late. Here comes Patrick at last.

PATRICK: Hi!

NARRATOR: Chantal is a little annoyed. Patrick apologizes for being late.

CHANTAL: You're late.

PATRICK: I know, I'm sorry. I was taking a test.

NARRATOR: What are Patrick and Chantal going to do now? Are they going to see a movie?

CHANTAL: So, you want to see a movie?

NARRATOR: ...or are they going to go get some coffee?

PATRICK: You want to go get a coffee?

NARRATOR: Then again, maybe they will go boating.

PATRICK: You want to go boating?

CHANTAL: Don't be silly, we can't! These boats are too small...

NARRATOR: What are they going to do? What are they going to do?

CHANTAL: You want to see a movie?

PATRICK: What movie do you want to see?

CHANTAL: A theater near here is showing *Celine and Julie Go Boating*.

PATRICK: What a funny name! It must be an interesting movie.

NARRATOR: It's an interesting movie... but a long one. After the movie, Chantal is tired.

PATRICK: Aren't you tired?

NARRATOR: She's really tired.

CHANTAL: I'm really tired.

NARRATOR: Patrick suggests she go home and get some rest.

PATRICK: You should go home and get some rest. I'll see you tomorrow.

NARRATOR: "See you tomorrow," says Chantal."

CHANTAL: OK, see you tomorrow.

Part II (see textbook, p. 36)

NARRATOR: Chantal is tired.

CHANTAL: I'm tired.

NARRATOR: She's really tired.

CHANTAL: I'm really tired.

NARRATOR: She's so tired.

CHANTAL: I'm so tired...

NARRATOR: Patrick suggests she go home and get some rest.

PATRICK: You should go home and get some rest. I'll see you tomorrow.

NARRATOR: "See you tomorrow," says Chantal.

CHANTAL: OK, see you tomorrow.

NARRATOR: Now you try the dialogue with Chantal.

CHANTAL: You want to see a movie?

YOU: _____ ?

CHANTAL: A theater near here is showing *Celine and Julie Go Boating*.

YOU: _____ .

NARRATOR: Now the movie is over. Ask Chantal if she is tired.

YOU: _____ ?

CHANTAL: Yeah, I'm really tired.

YOU: _____ .

CHANTAL: OK, see you tomorrow.

End of Lesson 15

Lesson 21 (see textbook, p. 79)

NARRATOR: Paris, Luxembourg Garden. Chantal is waiting for Patrick. What are Chantal and Patrick going to do this afternoon?

PATRICK: So, you want to see a movie?

CHANTAL: Do you want to go get a coffee?

NARRATOR: What are they going to do?

PATRICK: ...You want to go to your place?

NARRATOR: Chantal and Patrick decide to go for a coffee. They talk about this and that: the weather...

PATRICK: Do you think it's going to rain tonight?

NARRATOR: ...politics...

CHANTAL: Do you think the subway strike is going to end?

NARRATOR: ...love...

PATRICK: Do you think you're going to find the perfect man?

NARRATOR: Look who's here, it's Hubert.

HUBERT: Ah, my dear Chantal!

CHANTAL: Do you know Hubert?

HUBERT: May I?

PATRICK: Sure: the capitalist.

HUBERT: Come on, you make it sound like an insult.

NARRATOR: Patrick doesn't like Hubert.

PATRICK: No offense.

NARRATOR: Hubert doesn't like Patrick.

HUBERT: It's OK.

PATRICK: Well, I should be going.

CHANTAL: Already?

PATRICK: See you later.

CHANTAL: Sure.

HUBERT: 'Bye.

PATRICK: 'Bye.

HUBERT: Well then, Chantal...

End of Lesson 21

Lesson 22 (see textbook, p. 98)

NARRATOR: Paris, Luxembourg Garden. It's nice out. Chantal is taking a walk. She picks a flower. She starts to recite:

CHANTAL: He loves me...

NARRATOR: She wants to know if someone loves her... or not.

CHANTAL: ...a little... a lot... madly...

NARRATOR: But who could he be, this "someone"?

CHANTAL: ...not at all!

NARRATOR: Who could he be?

CHANTAL: He loves me... a little... a lot...